a visual
language

a visual language

language

SECOND EDITION

DAVID COHEN & SCOTT ANDERSON

Herbert Press
an imprint of Bloomsbury Publishing

First published in Great Britain in 2012 by
Bloomsbury Publishing Plc
50 Bedford Square
London
WC1B 3DP

ISBN: 978-1-4081-5222-5

Commissioning editor: Alison Hawkes
Assistant editor: Agnes Upshall
Page design: Susan McIntyre
Cover design: Sutchinda Thompson

Typeset in 10 on 12pt Myriad Pro light

This book is produced using paper that is made from wood grown in
managed, sustainable forests. It is natural, renewable and recyclable.
The logging and manufacturing processes conform to the environmental
regulations of the country of origin.

Printed and bound in China

CONTENTS

PREFACE

We need to give everyone the outlook of the artist, who begins with the art of seeing – and then in time we shall follow him into the seeing of art, even the creating of it.

Sir Patrick Geddes (1854–1932)

Since the first edition of *A Visual Language: Elements of Design*, we have reflected on our most successful approaches to teaching and learning. This edition presents what we believe is a coherent and holistic approach to applying visual language.

Visual language underpins our method for improving visual literacy, and remains central to what we hope the reader will understand and enjoy.

The elements of this language (line, shape, tone, colour, texture, form, scale, space and light) are explained. Colour illustrations guide the reader through a creative adventure that explores visual language in accessible ways. Our principal goal for this book is to improve the ability to see, in order to facilitate creative self-expression that has lasting value.

The elements of visual language are ubiquitous, often defined in design texts and conventionally referred to as *formal elements of design*. We ask: 'But why limit their definition to design alone?'

Narrow perspectives can restrict critical assessments that attempt to *link* composition with the maker's creative intention. Too often the critical focus is on technical competence or use of materials, where conversations centre on 'How?' instead of asking 'Why?'.

This text attempts to offer a broader understanding of the elements to embrace the maker's intention, opening a deeper discourse. Design plays an important role in successful composition, but thinking only about the elements in the context of design, leaves critical gaps in theory and practice. We prefer to use the term *visual elements* and apply these elements in composition holistically.

Whether you have little or no experience, consider yourself an amateur or professional, student or teacher, this book introduces you to visual literacy and the practice of seeing in unique and achievable ways.

We explain fundamental building blocks of visual language, upon which to construct knowledge and practise skills that are compounding and challenging, delivered through step-by-step exercises.

With meaningful and consistent practice, insight and confidence are developed to make successful visual decisions, along with the ability to research topics of personal interest and apply findings to create two- and three-dimensional work that truly reflects creative intentions.

Most importantly, questions relating to 'How?' and 'Why?' in the selection process are addressed through applying visual language to critically evaluate your work and the work of others. Negative

emotions that are a natural part of creativity no longer become barriers, and through experimentation, risk-taking, mistakes, accidents and wonderful surprises along the way, confidence and experience are developed. This is all part of learning to see.

After working through this book, we hope that the confidence and knowledge gained will provide a critical foundation to recognize and appreciate visual beauty, value and quality, with perhaps a sense of pleasure in understanding why.

ABOUT THIS BOOK

The Introduction defines visual language focusing on qualities inherent in the act of seeing. Two helpful models: 'Five building blocks to visual discipline' and 'Four key questions' clarify keywords and provide useful definitions to help focus and guide you through practice and critique of your work. The key questions help you to think visually and realise intention in your work.

Following the Introduction are five chapters. Chapters 1–4 provide succinct overviews of specific approaches, each one detailed and fully illustrated, with step-by-step exercises and explanations of skills and techniques to help you apply visual language in practice.

Chapter 5 concludes with a theoretical model for self-expression: the ultimate goal. Artists' examples of self-expression are provided at the end of every chapter. Chapter 5 is where all the chapters come together through professional artists providing examples and critiques of their work.

We hope that there is something for everyone in this book. For beginners, we recommend you to start at the front and work your way through patiently, consistently and methodically. The more experienced may find themselves dipping in and out depending on where their particular interests lie.

On some level, this book amounts to our working and teaching philosophy. On another it could be said to be our manifesto: 'a public declaration of policy and aims...' (Oxford Dictionary) or '...a public declaration of principles and intentions...' (Wikipedia). These definitions are quickly followed by the word 'political'. So be it. We hope this book finds its way into the hands of students, teachers and artists in need of perspectives in their quests for creative self-expression of value.

Chapter 1 **Non-representational drawing**

This chapter illustrates a series of seven non-representational drawing exercises. These step-by-step approaches help to build confidence with visual vocabulary and aid the understanding of visual decisions and composition without the need for any previous drawing experience, skills or talent.

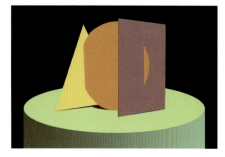

Chapter 2 **Two-dimensional plane to three-dimensional form**

This chapter continues non–representation in the transition from two- to three-dimensional composition, image rotation, plane and placement using geometric shapes. Seeing rotational space is introduced.

Chapter 3 **Representational drawing and abstract analysis**

This chapter introduces basic rules of perspective, then focuses on representational drawing: setting up and drawing still life, the life model and interior/exterior space. Representational drawing through academic observation is illustrated and discussed to reveal that geometric shapes through abstract analysis are intrinsic to the ability to see and draw subjects and objects in everyday life.

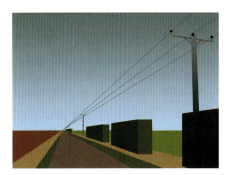

Chapter 4 **The figure**

This chapter introduces life drawing in an academic context and concludes with the use of the figure as a source of self-expression. Basic principles are covered; abstract analysis is explained and applied. The importance of expressing the character of the pose and the application of highly selected rendering is clarified.

Chapter 5 **Self-expression and visual practice**

This chapter introduces our model for best practice, highlighting the importance of drawing, the sketchbook and the development of ideas and research to realize intention through personal expression. Examples and first-hand accounts of professionals in the areas of craft, painting, sculpture, architecture, graphic design, photography and animation, provide an appreciation of how art and design professionals realize their ideas and express intention in their work. Their approaches to thinking and practice are revealed, providing unique insights into their work in relation to their visual language.

ACKNOWLEDGEMENTS

We extend our thanks and great appreciation to our featured artists: Colin McPherson, Liz Ogilvie, Robert Callender, Esther Cohen, Nathalie Ferrier, Suzy Rivitz and Daniel Sousa, who generously contributed valuable time, reflections on their practice and images of their work.

We also thank the artists whose work appears throughout the text for their kind permission to use images of their work. And to all those artists whose work cannot be identified by name, date or title, we blame poor archiving of our slides or having original unsigned artwork in our collection. We apologise for not acknowledging your work in the appropriate manner and hope you understand.

Some of the untitled works belong to David's students during his tenure as Head of Ceramics at Glasgow School of Art. We need to express our deep appreciation and gratitude to our students, who push us towards better methods, ask challenging questions, create quality work and demonstrate enthusiasm and a passion for learning. Without you, we have nothing to share.

On the journey to completing this second edition we have relied heavily on critical and emotional support from friends and family. In particular, we thank Dan McCullough and Joe Navas for their friendship and feedback. And finally a very special thank you to our wives, Frances Gardiner Cohen and Christine Anderson, who are the most patient, kind and loving people we will ever know.

INTRODUCTION

Learning visual vocabulary is as vital a part of learning how to see as learning any vocabulary in any discipline. Musical notation to compose music; the written word; numbers for mathematics – each vocabulary enables learning and understanding.

Mastery of a vocabulary is achieved over time through experience, skill development, repeated and meaningful practice, problem-solving, risk-taking, research and experimentation. These qualities culminate in understanding and make new discoveries possible. The same goes for the vocabulary of art and design. However, unlike reading, writing, maths and science, this opportunity is rarely provided in the formative years of our education.

At an early age we are introduced to the alphabet, then simple words, and eventually reading and writing sentences and paragraphs. In our introduction to numbers we learn simple addition, subtraction, multiplication and division.

In writing, our development towards literacy involves literal thinking, processed through our oral and written need to accurately identify and describe our environment using words. This is a conventional part of learning to communicate. By adulthood, an advanced literal vocabulary enables us to communicate in relatively complex ways.

The vocabularies of words and numbers are held in high regard, elevated in importance, the cornerstones of what is conventionally defined as 'educated'. Our ability to write in fundamentally organized, balanced, coherent composition and know with certainty that $2 + 2 = 4$ are things we have been educated to do since early childhood.

WHAT ABOUT VISUAL VOCABULARY?

Visual vocabulary (the language of visual elements and composition) is not regarded as an educational necessity like literacy, science and maths. As children we are encouraged to play and our early art-making in school is conventionally played out. It is a travesty, but on the journey from childhood to adulthood we forget how to play and end up visually illiterate.

This book attempts to address this loss by offering methods towards greater visual literacy.

The difference between looking and seeing: an approach and attitude

Pause for a moment, and answer this question: 'What is the difference between looking and seeing?' It's a simple question, but your response will help to realize your starting point in this text.

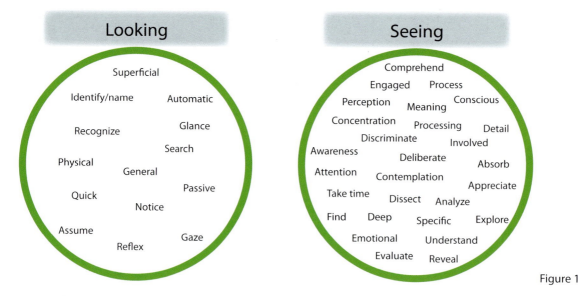

Figure 1

Figure 1 shows qualities that are often associated with looking and seeing.

Essentially, looking is passive and seeing is active. Seeing requires critical awareness, deep concentration and understanding to enable the observer to exercise his or her ability to discriminate on more than a superficial level.

This text requires active participation together with time, hard work, and energy when learning to see. Tangible and rewarding outcomes are possible with meaningful practice.

FIVE BUILDING BLOCKS TO VISUAL DISCIPLINE

When the qualities of seeing are engaged, an initial question to ask oneself is: 'What am I seeing for the purpose of creating art and design work?'

Figure 2 illustrates fundamentals in the act of seeing that, when applied in practice and critique, can help to appreciate, understand, evaluate and create two- or three-dimensional composition regardless of chosen medium or visual discipline. The diagram is a practical framework that can provide direction and guidance for creative approaches and development.

This framework is also a place to come back to for reflection, helping to re-focus attention on creating work that reflects intention. In turn, this helps to work through difficulties such as frustration and boredom.

There is nothing in this structure that deflects attention away from the importance of the work produced. This is what makes its application useful and applicable to any medium or visual discipline. It allows for a consistent critique and meaningful practice, which are essential for observable improvement and progress.

There is always danger in too much introspection where a desire to express feelings and emotions overpowers the critique. Then the critique enters entirely another dimension and the practical framework for seeing is often lost. This form of critique may be good (or bad!) therapy, but often interferes with the ability to see. When learning visual language, the critical focus should always be the composition and intention of the work in front of you.

Five building blocks to visual discipline

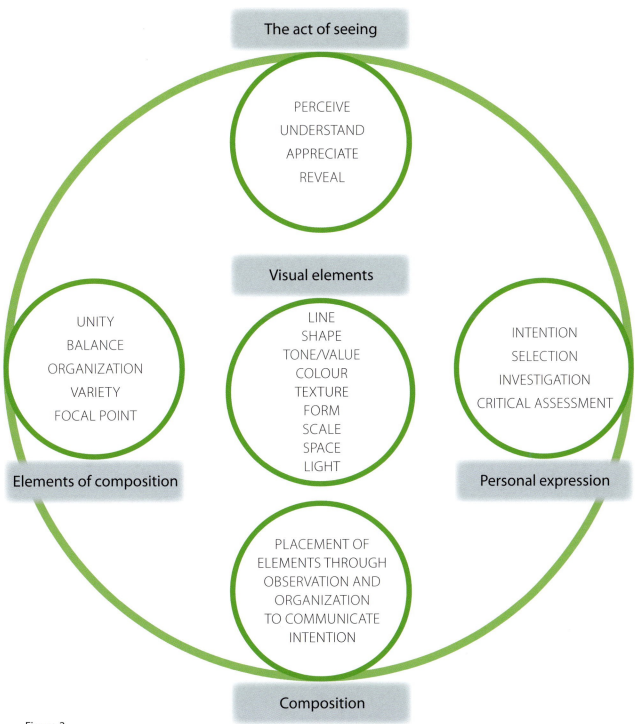

Figure 2

Five building blocks to visual discipline explained

The keywords explained below can be used like a compass pointing towards visual literacy.

At the centre of the framework in Figure 2 are visual elements (Figure 3). In the act of seeing, we realize that visual elements are ubiquitous. They are in both natural and artificial environments, in every art and design work ever created.

The act of seeing (Figure 4) is intrinsically linked to visual thinking (as opposed to literal thinking). Through visual thinking and seeing, it is possible to appreciate in purely visual (abstract) terms. In this context everything in our environment is analyzed using visual elements.

Try it. Take a moment now to see your surroundings. Stop naming things around you (your literal response), and try to see the visual elements in the space you're in (your visual response).

Do you see visual elements of line, shape, colour, texture and tone?

Congratulations! You've just taken your first steps towards seeing the world in visual and abstract terms. Abstract because you identify and make sense of the world through seeing visual elements: line, shape, tone, light, and space.

By revealing visual elements, your perception, understanding and appreciation of your surroundings have shifted from a passive/literal response (using words to name and identify) to an active/visual one (seeing visual elements through an abstract analysis).

As you become increasingly visually literate, it becomes second nature, and the shift from literal to visual thinking and abstract analysis becomes less challenging.

Visual elements will be critically evaluated throughout the text using art and design exercises and examples. This encourages an invitation to see, and applying the elements helps to develop visual vocabulary in artistic composition.

There is a tendency to overcomplicate what composition is (Figure 5). While challenging to put into successful practice, simplifying terms will help to realize what is attainable.

Finished composition is the result, the final 'see and feel' of art or design work, but it is the record of the visual decisions made along the way. It's your fingerprint, and identifies you as being responsible for those decisions during your creative process. It describes the visual elements you selected, where you placed them, and how they relate to each other. Composition is a visual play that can be interpreted on a number of levels, but ultimately expresses the intention of the maker.

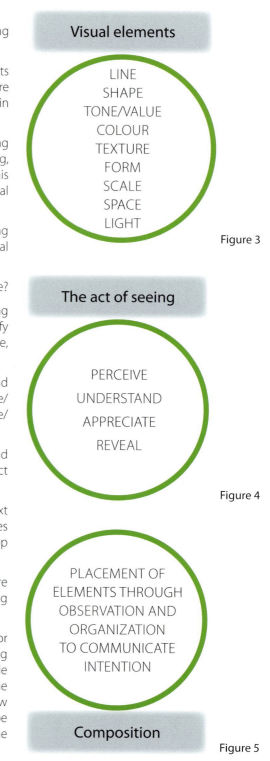

Visual elements

LINE
SHAPE
TONE/VALUE
COLOUR
TEXTURE
FORM
SCALE
SPACE
LIGHT

Figure 3

The act of seeing

PERCEIVE
UNDERSTAND
APPRECIATE
REVEAL

Figure 4

PLACEMENT OF ELEMENTS THROUGH OBSERVATION AND ORGANIZATION TO COMMUNICATE INTENTION

Composition

Figure 5

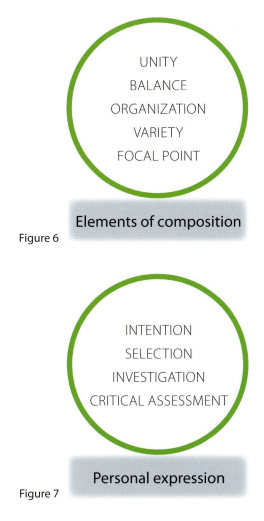

UNITY

BALANCE

ORGANIZATION

VARIETY

FOCAL POINT

Elements of composition

Figure 6

INTENTION

SELECTION

INVESTIGATION

CRITICAL ASSESSMENT

Personal expression

Figure 7

Composition is the selection, placement and organization of visual elements, through observation, to communicate intention. This definition could also be extended to drawing: drawing is composition, composition is drawing.

Composition requires research, experimentation, repeated practice, the act of seeing, abstract analysis, design and visual thinking. A sense of how to manipulate and explore visual balance, organization, unity, variety and focal point becomes possible through the application of these (Figure 6). Ultimately, the composition should possess visual impact and value for the viewer when everything comes together, expressing the artist's intention and aesthetic objective.

Personal or self-expression is the ultimate goal in mastering any language in any discipline (Figure 7). The decisions you make in composition are always your decisions. To accept this responsibility and be confident in your decision-making takes many hours of repetitive and meaningful practice.

To become clearer about your ideas and your intention requires investigation (research). Sources may include books, sketchbooks, journals, articles, images and writing. Investigation can also be carried out in meaningful, practical repetition and development of composition(s) or in a skill you are trying to master. Investigation always relates directly to your inner voice, the continual dialogue within that drives you towards ideas, locations, practices and/or materials of personal interest. This journey is not so much about the destination, more about what you discover along the way.

To remain open to possibilities, and to find your own way eventually are most important. Inner dialogue guides the ability to be selective. The selective process enables the ability to evaluate decisions and develop consistency and confidence.

The relationship between the five building blocks is important. In both practice and application they affect one another. It is a challenge to consider all aspects at all times, but this is a skill that comes with experience. The more you make, the more your ability to utilize vocabulary will increase.

Technical competence is not expressly discussed; however it is crucial because the mastery of language requires the mastery of craft and material. Technical competence and knowledge of the medium are never enough to fully realize intention: one can be technically competent but remain visually illiterate. Technical competency generally relates only to the mechanics of how a tool or the physical relationships of the material function. While very important, this competence will only serve to answer technical questions to solve technical problems.

FOUR KEY QUESTIONS

What am I interested in?	IDEA
What am I to do?	INTENTION
How am I to do it?	SELECTION
Why this way…? What if I…?	CRITICAL ASSESSMENT

These four questions can help to sustain enthusiasm, counter frustration and boredom, and add great value to creativity (Figure 8).

Asking these critical questions continuously when creating art and design work will help towards a deeper investigation of self in relationship to work and in turn lead to decisions concerning appropriate materials and design.

These questions appear simple but are challenging. At the beginning of a creative journey it is important to try to establish a sense of purpose and intention, otherwise it can become aimless and pointless. Things may happen along the way that force change, but these four questions remain at the heart of what matters most, no matter what changes happen. These questions help to realize starting point(s) to begin work, carry on through the process to reach conclusion(s) of lasting value and to encourage a new beginning. It is a cyclical involvement over time.

Time

One aspect of creativity that can never be taught is the concept of time. Any language, skill or material will take time to learn and understand, and every individual will require varying amounts of time to learn and practise. Be prepared to accept the inevitable frustrations that accompany the time it takes to achieve any lasting understanding and quality in your work. This text explains and illustrates methods and approaches to help you cope with frustrations. The time it will take to find success cannot be predicted.

The following chapters include visual exercises designed to provide a holistic approach to learning visual language. Knowledge and skills are compounded and the challenges grow in complexity as vocabulary becomes more familiar. Important advice and critical assessment are emphasized throughout the text for clarity and guidance so that mastery of visual language can be achieved and enjoyed.

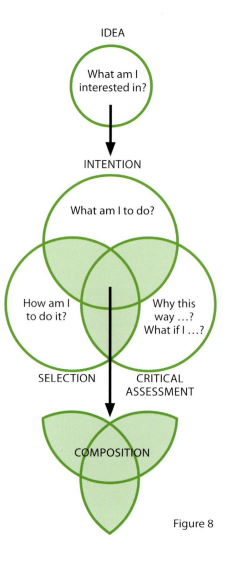

Figure 8

1 NON-REPRESENTATIONAL DRAWING

Conventional introductions to learning art and design (visual learning) are taught through projects that are often highly representational (draw or paint what you see and make it as 'lifelike' as possible) or abstract (do whatever you feel like doing!). Rarely are projects compounding or coherent in sequence over time.

This can result in a negative learning experience, when success is measured on a 'hit or miss' basis, with little understanding of why success was achieved in one project and not in another. Critique is focused on how much effort was put in and/or superficial 'like it' or 'dislike it' aesthetic responses. Learners can be intimidated, frustrated and confused.

This text approaches visual learning sequentially. The value of compounding visual learning and critique makes clear relationships between what was made before and what comes next, and explains why.

Each chapter in this book builds on the previous one in skill, knowledge and compositional complexity, so the learner can develop a coherent and lasting understanding. This text is designed to expand their visual vocabulary and help develop a portfolio for critique. The learner should eventually *be able to reflect on his or her own work* and understand what led to successful and less successful results.

WHY START HERE?

This chapter illustrates a series of seven non-representational drawings. As our method of introducing seeing and visual decision-making, these exercises have proved successful for anyone trying to understand and apply composition and realize creative intentions. The exercises create a strong visual foundation and a clear pathway to increasingly complex learning and skill-acquisition in two- and three-dimensional work.

Non-representational drawing helps to focus the maker's attention directly. There is no need to see beyond the boundary of the drawing paper. Full concentration on visual elements and their relationships in composition can be seen, critiqued and understood.

Non-representational drawing is introduced before representational drawing, so that confidence can grow and principles of composition can be experienced and understood in a less intimidating way. These drawings are designed to enable successful visual decisions and the expression of intention.

Seeing visual elements in a non-representational context prepares the learner for the challenges of observation and selection. Observational skills reveal the elements through abstract analysis. Without these skills and practice, abstract analysis in representational drawing can be overwhelming and progress towards visual literacy compromised.

Non-representational drawing fosters confidence and with enthusiasm for meaningful practice, these qualities become more valuable to success than skill or talent.

This chapter introduces non-representational drawings that are designed to help you see visual relationships between the elements, for their own sake. This practice promotes more focus on the composition.

Visual elements form the foundation of successful composition. Through placement and organization of elements, selection, intention, balance and variety can be explored.

Visual elements are the vocabulary upon which decisions concerning composition and intention can be made clear.

After completing this chapter you will be able to:

- define non-representational drawing
- identify and apply visual elements
- create a focal point using visual elements
- develop intention in your work
- compose using visual elements
- critically assess your drawings
- define composition.

Figure 9 illustrates seven non-representational drawings in sequence and increasing complexity.

MATERIALS AND BEST PRACTICE

Before beginning any drawing it is always a good idea to have Figures 2 (Five building blocks to visual discipline) and 8 (Four key questions) at hand for reference. These diagrams help to focus on essential components of composition and intention.

The phrase 'practice makes perfect' holds true. Visual literacy grows with experience and this comes with meaningful and consistent practice. The more work is made, the more opportunity for critical assessment and constructive dialogue.

Each drawing is described in step-by-step detail and includes advice and critical assessment.

You will need the following materials to complete the drawings in this chapter:

- A2 or 18 x 24-inch drawing pad (not newsprint) *
- sharp cutting knife and scissors
- 1-inch masking tape
- 12-inch ruler
- fine, large and extra-large black ink marker pens
- A4 (or 8 x 11-inch) coloured construction paper that must include a minimum of 6 sheets of black, 4 sheets of yellow, 4 sheets of blue and 4 sheets of red
- 4 sheets of A4 (or 8 x 11-inch) contrasting grey paper: 2 of light grey and 2 of dark grey.

* It is important to draw on an A2 or 18 x 24-inch piece of paper. The challenge in achieving successful composition on a large piece of paper is greater. You will be able to see more clearly your successful and less successful decisions when drawing on a larger piece of paper. Weaknesses are magnified; this is important for critique and your ability to make progress in the beginning.

Figure 9

NON-REPRESENTATIONAL EXERCISES

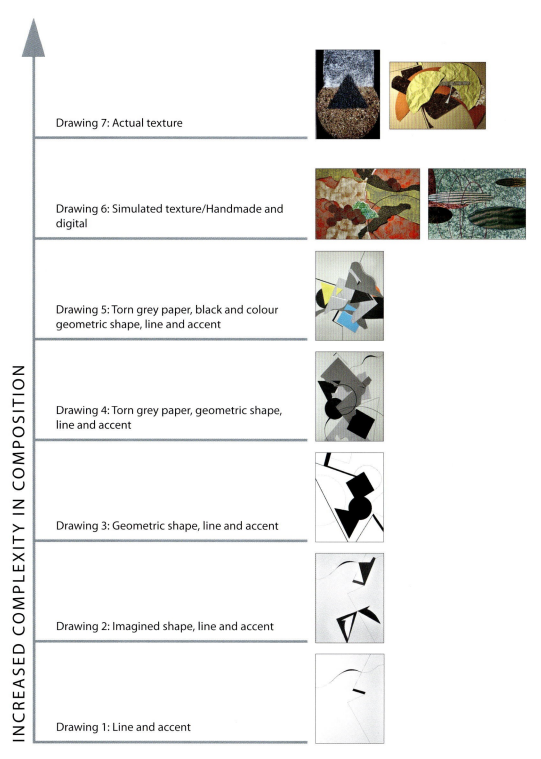

INCREASED COMPLEXITY IN COMPOSITION

Drawing 7: Actual texture

Drawing 6: Simulated texture/Handmade and digital

Drawing 5: Torn grey paper, black and colour geometric shape, line and accent

Drawing 4: Torn grey paper, geometric shape, line and accent

Drawing 3: Geometric shape, line and accent

Drawing 2: Imagined shape, line and accent

Drawing 1: Line and accent

INTRODUCING LINE

The visual power of a dot

Figure 10 Figure 11

A blank piece of paper (Figure 10) is seen and experienced as empty white space. The outer edges of the paper contain this space in a frame. Every time a mark is made in this space, visual change takes place. Critical assessments of changes are essential to improve decision-making in composition. Keeping composition and visual decisions simple are good intentions to have when beginning to learn visual language.

A dot (Figure 11) is perhaps the simplest mark one can make on a piece of paper. A single dot placed anywhere in the frame of white space has the visual impact of steering the viewer to that mark. The dot becomes the point of interest, a highlight and visual accent, commonly known as the focal point.

Connecting dots in a line

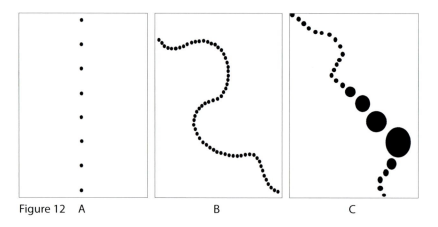

Figure 12 A B C

When dots are placed next to each other in various ways (Figure 12, A–C), a visual relationship or dialogue between them emerges. In these examples the intentions are clear: in A, the dots are placed and organized in a conventional manner, to create a straight line; in B, a fluid, expressive line emerges; a focal point is established in C by introducing a variation in scale. The larger dots placed in close proximity to each other create visual accent or weight that steers the eye towards them. This is a powerful and important realization: the maker applies the decision to direct the eye of the viewer in the composition.

Literal thinking and line

Task: Divide a piece of paper into two equal parts using a drawn line.

The conventional approach results in one of three solutions: a horizontal, diagonal or vertical line (Figure 13).

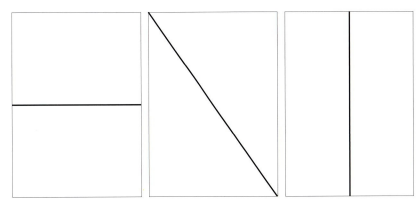

Figure 13

Conventional, literal responses have creative limitations, lacking individuality. The next three approaches to the task (Figure 14) are more inventive and express the individuality of the maker. This demonstrates the importance of thinking outside convention and considering creative solutions. The range of possibilities is infinite and depends on accumulated knowledge, experience and practice. By repeating this task the results would express individuality. With understanding and increased vocabulary, individuality can be expressed.

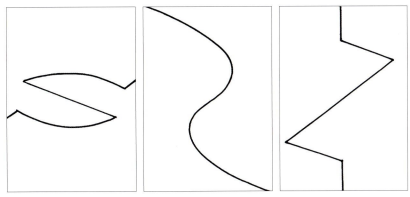

Figure 14

SEEING SHAPE AND NEGATIVE SHAPE

A continuous drawn line (Figure 15) has the effect of dividing white space to create two distinct shapes (A and B). These can be described as the negative shapes or negative spaces.

It is essential to see negative shapes 'left over' in the surrounding white space, after solid (positive) elements (such as line) are added to the composition.

Figure 15

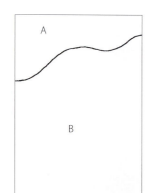

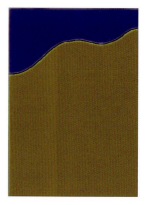

1. The horizontal line is a positive drawn mark that divides the white space into two negative shapes A and B.

2. Two tones are used to clearly illustrate the negative shapes A and B.

DRAWING 1: Steps 1–4

Line and accent, negative shape and focal point

Important advice
Keep drawings simple. Complicated lines and accents make it difficult to achieve balance, unity and organization in the composition.

Step 1 Divide the drawing paper with a continuous drawn line in the top third of the paper (Figure 16).

Critical assessment The drawn line is flowing and organic in character, and has divided the paper, creating two negative shapes (A and B).

Step 2 Draw one vertical line that contrasts with the horizontal line.

Critical assessment The character of the line is geometric and contrasts with the flowing horizontal line. This creates variety. The vertical line has divided the paper again and created four negative shapes (C D E F). The lines intersect, and are of equal thickness/weight and importance.

Step 3 Accent a portion of the horizontal line.

Critical assessment The accent creates a focal point which steers the viewer's attention to the upper part of the drawing.

Step 4 Accent a portion of the vertical line.

Figure 16 Step 1 Step 2 Step 3 Step 4

Critical assessment The accent on the vertical line helps to redress balance in the composition by weakening the single accent and therefore weakening the focal point. The two lines and two accents, together with the four negative shapes, are now in dialogue with each other in a balanced and organized way.

The unity of all the elements and shapes is an aesthetic intention and the compositional goal for success.

DRAWING 2: Steps 1–5

Line, accent, negative shape, focal point and imagined (non-representational) solid shapes

The same lines and accents in Drawing 1, Step 4 (above) are used to begin Drawing 2, Step 1.

Step 1 Preparing a solid black imagined shape.

Cut out one simple, imagined, non-representational, solid black shape (Figure 17). Roll some masking tape on its end and stick to the back of the shape. This enables the shape to be easily moved around until the decision to place it is made.

Figure 17

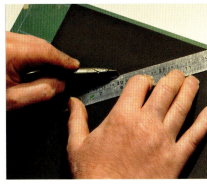

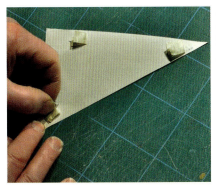

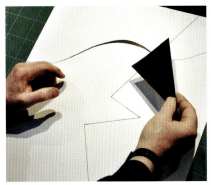

Step 1 Cutting out a black shape **Step 2** Attaching tape **Step 3** Deciding where to place the shape

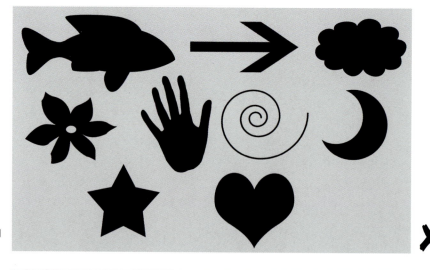

Figure 18
Common representational
(literal) imagined shapes.

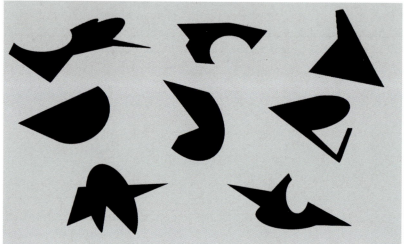

Figure 19
Non-representational
imagined shapes.

Important advice

The context for these drawings is non-representational (Figure 19). Never be tempted to imagine a representational shape (Figure 18) – a shape that can be identified with something that exists. 'Literal thinking' is a conventional response; it's how we communicate most of the time. However, this will destroy the unity and intention of the non-representational composition. Representational (literal) shapes will dominate and the composition will make no visual sense.

Step 2 Placing the first imagined shape.

Find a location in the composition for the imagined cut-out shape. Play with possibilities for appropriate placement and organization of the shape (Figure 20). This exploration is necessary to discover intention for the shape's placement. Where the shape is best located is an aesthetic selection and decision informed by existing relationships of space, line and accent in the composition.

Critical assessment Appreciate how the surrounding space and negative shapes visually change depending on where the shape is located, either touching a line or in isolated space.

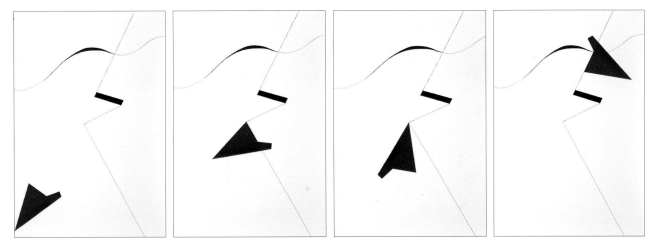

Figure 20

Important advice

Always be in a state of play and never hurry to find a conclusion. Take time to critically evaluate visual strengths and weaknesses before deciding to change the composition. Only when intention for a shape's placement is satisfied in relation to the lines and accents should the next step be taken. Never adopt the attitude of 'hope for the best' or rely on luck to place your shapes. Practise seeing and applying intention.

Step 3 Placing the second imagined shape.

Cut out a second solid black imagined shape that in some way visually complements the first cut-out shape (Figure 21). Critical assessment of the composition is the same as before, but now there are increasingly complex visual relationships to explore. Every additional element in composition increases complexity.

Critical assessment Reflect on the character of the second imagined shape. Try to complement the shapes, lines and negative shapes already in the composition. This will help unity and balance.

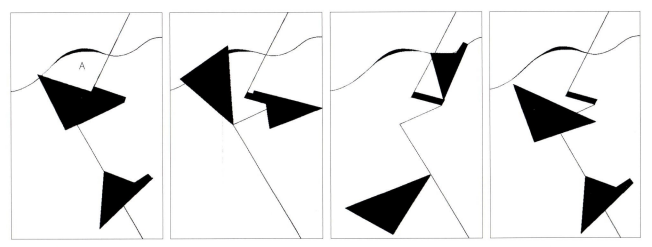

Figure 21

Important advice

Pay close attention to the negative shapes 'left over' after the positive lines, accents and black solid shapes have been placed. See the letter A in the negative space (Figure 21). There are a total of five negative spaces in this drawing. Can you see the other four? Count the number of negative shapes in the other drawings and see how the negative shapes change as a result of varying the placement and organization of the solid shapes.

The negative shapes create additional shapes of interest and can add great variety and interest to the composition. Pay particular attention to negative shapes.

Step 4 Take the second solid black shape off the composition and cut an additional solid imagined shape out from the centre of the second shape as shown in Figure 22.

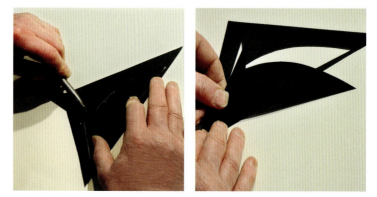

Step 5 There are three black cut-out shapes. One is solid, the second has a hole in it (a negative shape) and the third solid shape cut from the second shape reflects the cut-out negative shape. Place all the shapes into the composition.

Figure 22

Critical assessment The examples in Figure 23 A–C illustrate variations in composition using similar imagined shapes, lines and accents. The solid triangle shape in A is isolated in space. This 'floating' sensation doesn't help its relationship and unity with the other shapes. The accent on the vertical line does not complement the negative space of the cut-out imagined shape. It doesn't feel visually balanced.

The composition in B is more unified and balanced. The negative shapes are stronger and the shapes connect in more meaningful ways to the vertical and horizontal lines and accents. The composition in C uses organic, fluid lines and accents that contrast with the geometric cut-out shapes, creating a strong focal point.

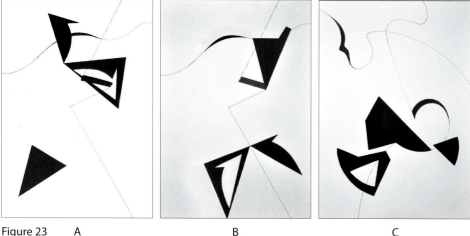

Figure 23 A B C

DRAWING 3: Steps 1–2

Geometric shapes: line, accent and focal point

This composition begins by cutting out three solid black geometric shapes: a circle, square and triangle. The shapes establish a geometric context for this composition.

Step 1 Cut out a solid black circle, square and triangle (Figure 24 A). Make them large enough to have visual command on the paper. Play with a variety of different placements to explore spatial, shape and negative shape relationships. Start by placing one shape on the paper (Figure 24 B), add another (Figure 24 C) and finally place the third shape (Figure 24 D). Continually evaluate the shape and space relationships as the composition changes.

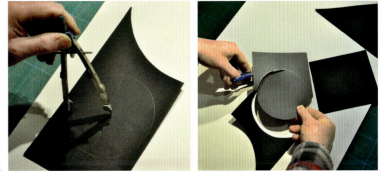

Figure 24 A

Drawings should be repeated several times until a dialogue is established between the maker and their drawings. Only through visual comparison can any critical basis for success be seen and evaluated.

Critical assessment In Figure 24 C–G the shapes begin to develop a visual relationship (dialogue) with one another. In C and D the shapes are anchored to the edges of the paper, creating a stable composition and a formal dialogue between the shapes. E places the square and circle at the centre of the composition in a closer relationship with the triangle, creating a strong focal point with the close group.

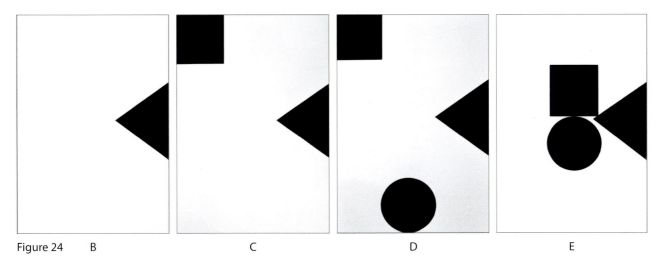

Figure 24 B C D E

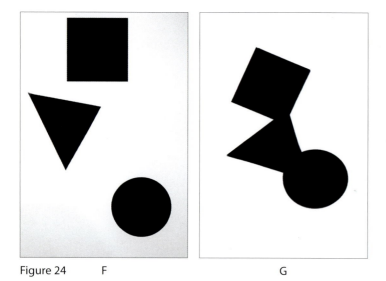

Figure 24 F G

Compositions F and G explore the shapes inside the frame of the paper; neither composition has a shape anchored to the edge. This creates a feeling of movement and weightlessness. In G, the shapes overlap each other, creating a group that could be seen as one shape, and a strong focal point in the composition.

Step 2 When satisfied with placement and organization of geometric shapes, draw black lines and accents to explore unity, balance and especially variety (visual interest) in the composition (Figure 25 A and B). This can be achieved with lines of various weights (thickness).

Critical assessment In Figure 25 A and B, appreciate the variation in weight of the drawn lines and accents and the resulting strong negative geometric shapes that complement the solid geometric shapes. This geometric reflection helps balance and unity. The accented lines help to steer the viewer from top left to bottom right and towards the focal point (the group of solid black shapes). B has a larger square, creating a more dominant focal point and feeling of weight.

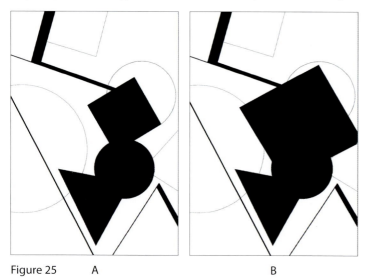

Figure 25 A B

DRAWING 4

Value/tone: torn grey paper, solid black geometric shapes, lines and accent and focal point

Step 1 Cut out another circle, square and triangle. You will also need two sheets of contrasting grey paper: a light grey and a dark grey (Figure 26) hand-torn diagonally as illustrated in Figure 27. After tearing the paper, notice the variety of line created by the contrasting edges. The right-angled, factory edge contrasts with the rough, hand-torn edge. This contrast adds variety to be explored when placing and organizing the shapes on the drawing paper.

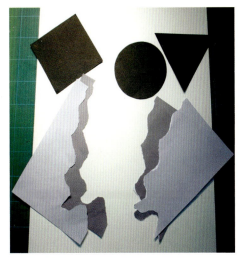

Figure 26

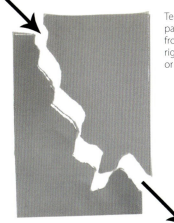

Tear both pieces of grey paper diagonally by hand from top left to bottom right. Do not use a knife or scissors.

Figure 27

Step 2 When placing the grey paper (Figure 28 A), play with various groupings until an appropriate placement is selected that expresses interesting visual relationships between shape and negative space.

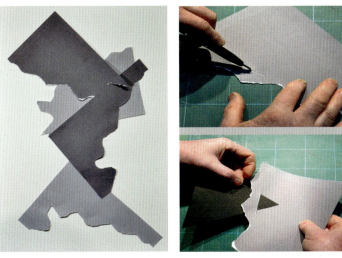

Figure 28 A B

Important advice

As the complexity of elements increases, the compositional goals of organization and balance become more challenging. The composition should not look like random 'stuck-on bits of paper'; all the elements must relate to each other in a unified way.

With the addition of the solid black geometric shapes (Figure 28 C–E) the technique of 'slicing' (Figure 28 B and C) provides visual options for concealing and revealing them. This will help to achieve unity. Allow yourself time to play and explore before you commit to placement. Do not alter the shapes' integrity by cutting additional shapes or holes in them.

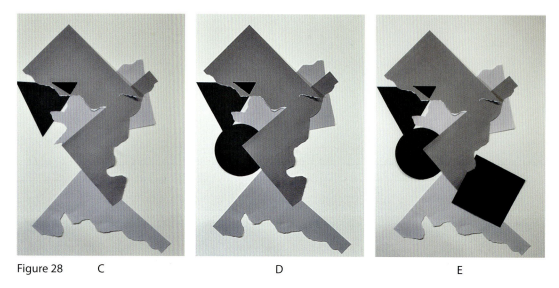

Figure 28 C D E

Step 3 The careful selection and placement of drawn lines and accents concludes this composition (Figures 29 A–C and 30 A and B).

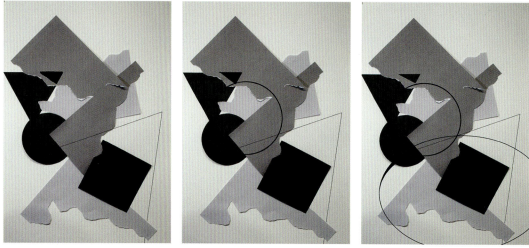

Figure 29 A B C

Critical assessment The lines and accents build variety in the composition and make intention and focal point clearer. The drawn lines (Figure 29 A–C) are of a geometric nature, circular and triangular to complement the black shapes.

The organic accented line in the top right of the composition (Figure 30 A and B) adds variety and complements the torn edges of the grey paper. This accent steers the viewer towards the shapes.

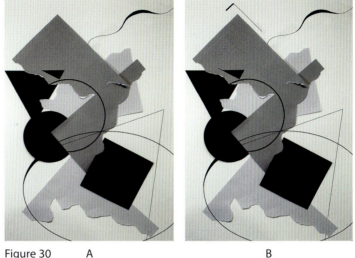

Figure 30 A B

DRAWING 5

Colour: cut grey paper, black geometric shapes, coloured geometric shapes, line, accent and focal point

Step 1 Prepare two sheets of contrasting grey paper, but this time cut (don't tear) the grey paper in a similar diagonal direction to that illustrated in Figure 27. Arrange the grey paper in a group (Figure 31 A and B) and consider slicing techniques (C), to integrate, reveal and conceal the shapes.

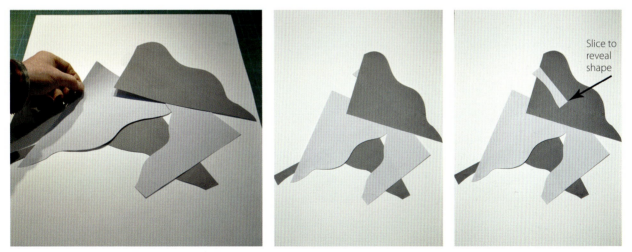

Slice to reveal shape

Figure 31 A B C

Step 2 Prepare a set of solid black geometric shapes (circle, square and triangle) and integrate them into the composition. The dominance of the black shapes' relationships creates a horizontal movement in Figure 32 A–C. Consider slicing techniques to conceal and reveal the shapes.

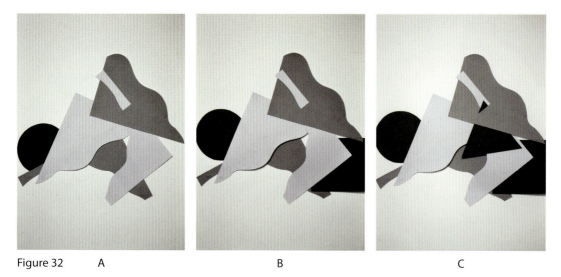

Figure 32 A B C

Step 3 Prepare a set of solid geometric coloured shapes (yellow triangle, blue square and red circle), similar in scale to the black solid shapes (Figure 33 A–D). Additional slicing techniques can be applied to reveal and conceal the coloured shapes.

Critical assessment The yellow triangle (Figure 33 A) points towards the black triangle and maintains a central focus to the composition. With the addition of the blue square (Figure 33 B) the slice in the grey paper creates a rhythmic line across the square in a horizontal direction. The red circles in C and D are placed differently. In C the red circle is dominant in the top right and distracts from the intention of retaining a strong horizontal composition. In D the intention is re-established and resolved by concealing the red circle on the far right and very subtly revealing a small part to steer the viewer to the far right and conclude the placement of the coloured shapes.

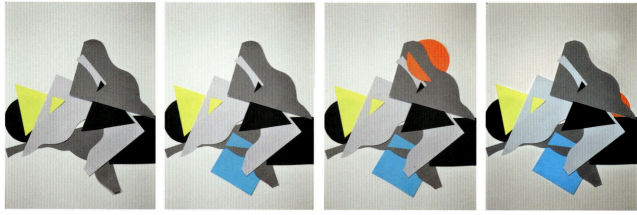

Figure 33 A B C D

Step 4 When the group of shapes is in place, the composition is ready for the final addition of drawn line and accent (Figure 34 A and B).

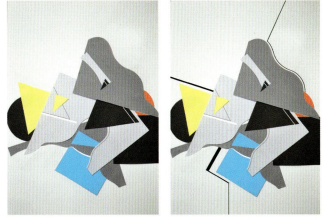

Figure 34 A B

Important advice

Imagine composition like a piece of fine jewellery. When the structure (the big shapes) is in place, the time comes to consider the 'jewels' (the slices, drawn lines and accents): the details that will make the composition sparkle.

Critical assessment In Figure 34 A, simple cut and drawn lines create echoes and rhythms with the existing shapes and contours, creating variety and a central focus to the composition. Details and accents steer the viewer to particular places in the composition, based on intention. To finalize the composition (Figure 34 B), contour lines follow the solid shapes. The black lines have visual impact and complement the horizontal group. Focal interest is centered and negative shapes that support the whole are defined in a unified and balanced composition.

A digital camera, computer and printer can be used to print images of the composition (Figure 35). By adding drawn line and accent on the printed image, intention can be explored.

Figure 35 Exploring line and accent using digital prints.

DRAWING 6

Simulated texture: handmade and photographic composition

Handmade simulated texture

Step 1 The examples in Figure 36 illustrate a variety of approaches to creating simulated texture. Simulated texture is the illusion of an actual texture on a two-dimensional surface. These illusions are all around us: on veneered surfaces, linoleum flooring, fabrics, plastics, wallpaper and print.

Take time to play with the creation of a simulated texture 'palette' that can be applied in composition.

Important advice

It will not take long to make a variety of simulated textures. The question is: What to do with them? Simulated textures are visually stimulating and varied in their own right and can make intention, selection and decision-making in composition challenging.

Figure 36 Creating simulated texture techniques.

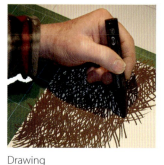
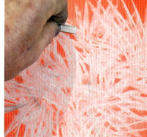
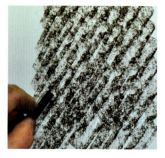

Drawing

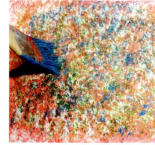
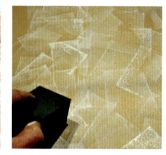
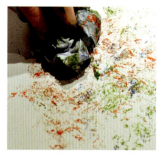

Rubbing

Brush

Sponge

Rag

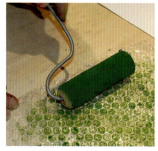
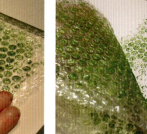
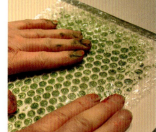

Roller

When placing and organizing simulated textures keep focal point, organization, balance and unity in mind, or the composition can end up confusing. Stay focused, work slowly, and keep the composition simple. Pay attention to selection and placement of visual elements at all times.

Look back at previous non-representational drawings in this chapter and use them as a visual reference for starting simulated texture composition. The drawings in this chapter are compounding, so they apply everything that has been learned. Don't let the visual complexity of this composition distract the intention of balance and unity. Take time to critically assess decisions.

Critical assessment The palette in Figure 37 A has been arranged using simple geometric shapes. It is beginning to appear organized but lacks focal point and interest. In Figure 37 B, the shapes have been cut into more interesting forms, negative space begins to appear and there is more balance and variety in the composition. The lack of focal point, however, leaves the eye wandering around without a clear sense of where to focus. These are typical results when selection and intention are unclear.

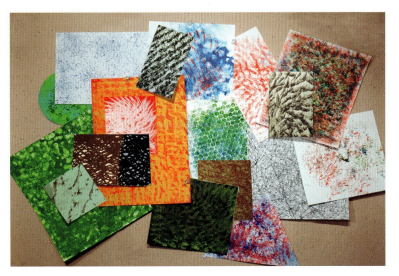

Figure 37 A

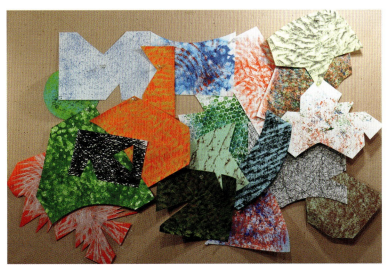

Figure 37 B

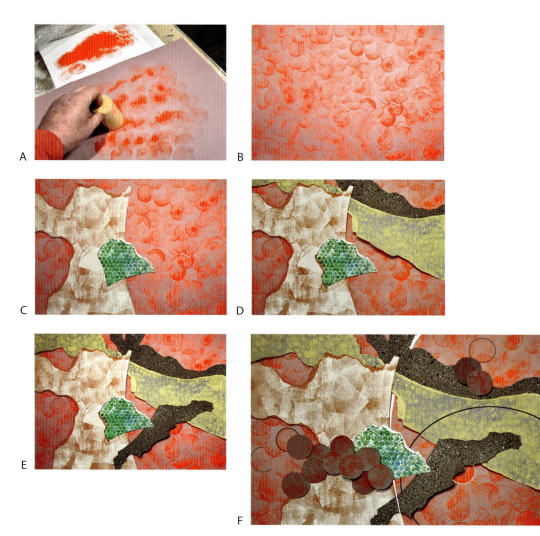

Figure 38

The simulated texture background in Figure 38 A and B was created with a sponge. Additional simulated textures (C, D and E) are selected and carefully torn and cut into defined shapes, then placed and organized to create variety. The final composition (F) is balanced and unified by the addition of line and accent to complement the circular theme in the composition. Without line and accent, this composition lacks intention and a focal point.

Computer-generated simulated texture

Computer-imaging software and a photo printer can provide an alternative approach to creating simulated textures. Using printed photo manipulations (Figure 39), the approach, advice and critique don't change, only the means by which the textures are made. Selection has to remain particularly acute when making critical decisions about graphic simulated textures.

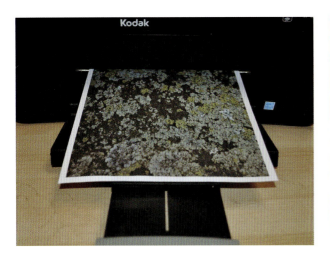

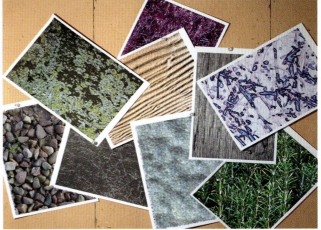

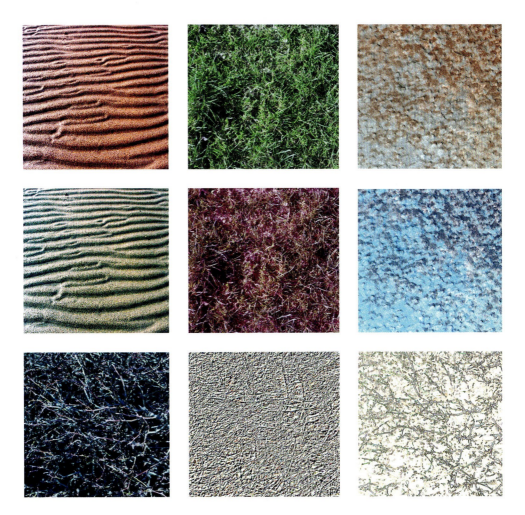

Figure 39

Critical assessment Approaches may include generating a digital drawing with drawing software (Figure 40 B, C and D). Alternatively, print the textures and begin in a similar way to the hand-made approaches described earlier (Figure 36). Either way, the composition will still require careful selection and intention.

The compositions in Figure 40 A–D were created on a computer, using a variety of digitally generated simulated textures. The starting point for A is an earlier drawing (Figure 25 B). When using textures it is a good strategy to use or refer to compositions from previous drawings, so that visual complexity does not overwhelm intention.

The complexity can be built up, but the underlying strength of the composition remains in place. The variation that can be achieved using a familiar starting point and working in a series creates critical and visual dialogue between compositions, resulting in further development and new discoveries.

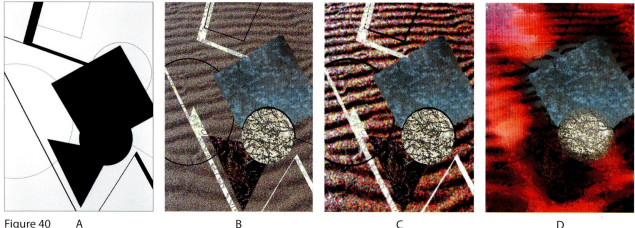

Figure 40 A B C D

DRAWING 7

Actual texture

This is the final non-representational drawing in the series. The exploration of actual texture can take many forms; the challenge as always is to create a composition that is organized, balanced and unified. This drawing requires a similar starting point to that of simulated texture. Create a palette of textured materials and then organize and place them depending on your intention.

Important advice
Try not to go in search of materials that are too unrelated to each other. (If the final composition looks like a bunch of stuck-on garbage, then it probably is!)

Great results can be achieved using only paper; tracing paper, coloured paper, cardboard, newsprint, newspaper, craft paper, etc. Fold, weave, crumple, cut, slice, shred, and tear selected paper in an infinite number of ways. The fact that the materials have paper in common helps to establish a visual and tactile context, leading to unity in the composition.

Like simulated texture, actual textures can be visually distracting, resulting in confusion and even frustration. Reflect on the strengths of previous drawings and consider using one of them as a starting point for this drawing.

Step 1 Adhesive spray or glue (Figure 41 A) can be used to stick textured material to a surface (the material is fine wood chips and sawdust (B)), resulting in an actual textured surface. After dumping the excess material (C) shapes can be cut (D). Other textures in D are wood shavings and crumpled paper. Line and accent have been added to create balance in the composition. This composition also uses plain coloured paper and simulated textures to create variety.

Figure 42 A–C demonstrates three compositions using a variety of materials: wood shavings, burnt wood chips, burnt paper and cardboard, burnt sawdust, coloured plastic and straw. What is important to appreciate is that the placement and organization of these materials result in compositions that retain a sense of unity and intention because of the decision to use geometric shapes throughout.

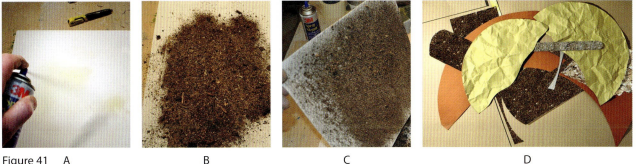

Figure 41　A　　　　　　　　B　　　　　　　　C　　　　　　　　D

Figure 42　　　　A　　　　　　　　　　　B　　　　　　　　　　　C

PERSONAL EXPRESSION USING TWO-DIMENSIONAL, NON-REPRESENTATION

In conclusion, here are five examples of plate compositions by ceramic artist David Cohen. Each composition illustrates a non-representational, geometric theme, considering placement and organization of line, colour, texture, form and shape.

Cohen's geometric approaches result in a personal play and exploration of line and geometric shape, form, colour and texture for their own sake. This play creates infinite compositional and visual possibilities in aesthetic and elemental relationships.

This creative involvement becomes Cohen's visual language and through his expressive intentions the compositions have aesthetic value.

The meaning of the work lies in the visual play between line, form, colour, shape and texture, elements composed by Cohen's mastery of visual language, craft and intention.

Meaning is defined in simple visual and aesthetic terms. Searching for literal or representational meaning(s) invites confusion on the part of the viewer because this context is wrong. If the context for the work is non-representational, then meaning(s) and value will also be discovered in non-representational appreciation.

The composition in Figure 43 is an example of the beauty and value of exploring visual play. Visual discoveries are made in the compositional permutations using the same four plates and arranging them in three different ways. Cohen applies his visual vocabulary to engage in a personal dialogue to explore infinite visual possibilities in composition. The process becomes exciting and provides the viewer with much to reflect upon and enjoy.

Compositions 44, 45 and 46 are further examples of Cohen's involvement with plate composition using non-representational geometric approaches. The slip-cast technique enables the accurate production of each plate from a plaster mould. With a combination of sandblasting and glaze decoration, the surface of each plate can be designed to hang in relationship to the plate next to it. Careful decoration, selection, placement and organization of each plate create unity and variety in balanced composition.

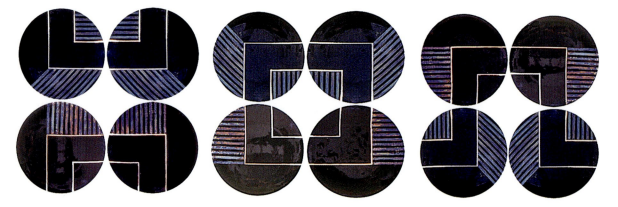

Figure 43 David Cohen, 1989. Slip-cast ceramic plate composition. Each plate 29 cm diameter.

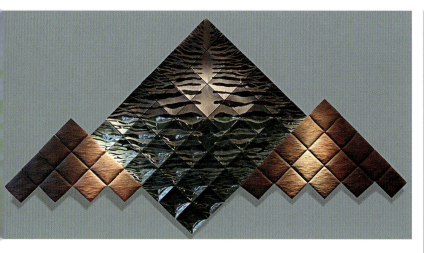

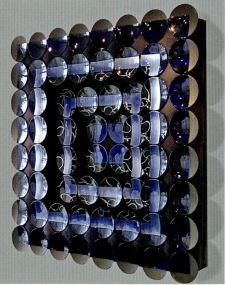

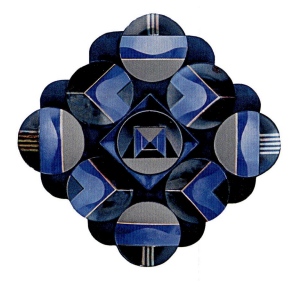

Figure 44 (*above; left and right*) David Cohen, 1996. Slip-cast ceramic plate compositions on wooden support frame. Each plate 29 cm diameter.

Figure 45 (*left*) David Cohen, 1998. Slip-cast ceramic plate composition on padded textile and wooden frame. Each plate 29 cm diameter.

Figure 46 (*below*) David Cohen, 2001. Slip-cast ceramic plate composition on plywood support frame. Each plate 29 cm diameter.

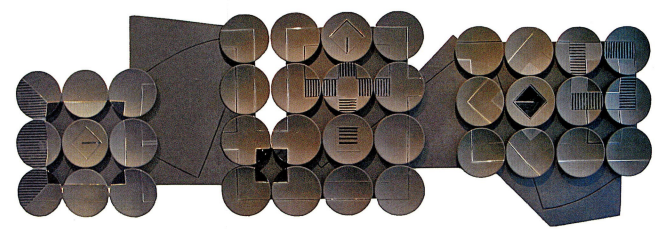

2 TWO-DIMENSIONAL PLANE TO THREE-DIMENSIONAL FORM

Everything that has been applied in non-representational drawing should be carried forward in the transition towards exploring non-representational three-dimensional form and the additional element of space and three-dimensional composition.

Figure 47 illustrates six steps in transition from two-dimensional to three-dimensional composition. In the examples, simplicity and consistency are maintained for clarity and coherence. The use of geometric shapes similar to those used in Chapter 1 enables visual connections to be made and helps to compound knowledge and skills.

After completing this chapter you will be able to:

- create three-dimensional form using basic geometric shapes
- develop a three-dimensional composition from a two-dimensional drawing
- identify and apply visual elements in three-dimensional composition
- develop intention in your work
- critically assess your composition using visual language
- see composition in a 360-degree, rotational context.

MATERIALS AND BEST PRACTICE

Before starting it is a good idea to have Figures 2 (Five building blocks to visual language) and 8 (Four key questions) at hand for reference, and to stay focused on the essential components of composition.

Materials needed:

- coloured paper
- coloured card stock
- cardboard
- wire
- toothpicks
- string
- coloured drinking straws
- sharp cutting knife
- masking tape and glue.

Figure 47

GEOMETRIC SHAPES: 2D TO 3D EXERCISES

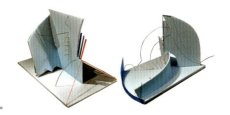

TRANSITION FROM 2D TO 3D COMPOSITION

Step 6: Colour geometric shapes, line, accent, enclosed negative shape and space in three-dimensional rotation

Step 5: Colour geometric shapes and line in three-dimensional rotation

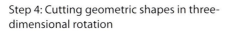

Step 4: Cutting geometric shapes in three-dimensional rotation

Step 3: Folding geometric shapes in three-dimensional rotation

Step 2: Geometric shapes in three-dimensional rotation

Step 1: Two-dimensional drawing and relief

TWO-DIMENSIONAL DRAWING AND RELIEF

Step 1 Figure 48 A–C.

A Draw a variety of simple geometric shapes on good quality, heavy-weight drawing paper of any colour. The paper is a two-dimensional planar surface.

B Red lines indicate a knife cut and green lines indicate a fold in the paper. The cuts and folds create high relief from the flat plane when the shapes protrude from the surface (Figure 48 C). This is an initial step to be explored in the transition to three-dimensional form.

C The composition is complete, mounted on a blue background to accent the negative shapes created by cuts and folds. This is a two-dimensional composition in high relief. The relief creates visual variation in composition. The composition, relief shape and negative shape change when viewed from different positions. Two-dimensional composition is conventionally seen from a single, static viewpoint. Relief and three-dimensional composition necessitate an assessment of multiple dimensions in space. Dimensions in space invite various viewpoints. The principal challenge in three-dimensional composition is the critical assessment of various viewpoints around 360 degrees.

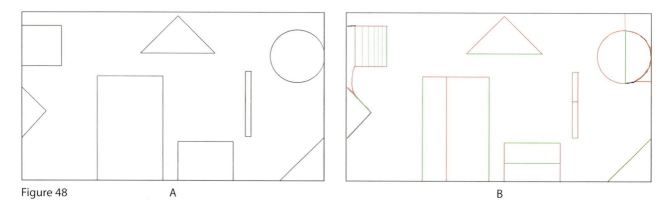

Figure 48 A B

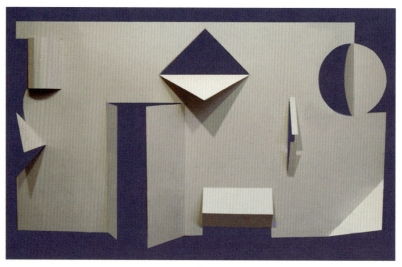

C

FREE-STANDING GEOMETRIC SHAPES IN THREE-DIMENSIONAL ROTATION

Step 2 Create three geometric shapes: circle, square and triangle from cardboard or heavy card stock (Figure 49 A). Make each shape a different colour. To make them stand upright (Figure 49 B), make a vertical slice in the triangle and the square and push the circle through so that the three shapes interlock and stand as one unit (Figure 49 C).

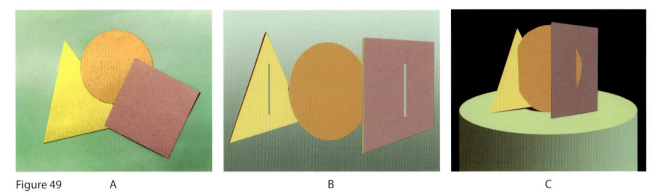

Figure 49 A B C

Critical assessment Seeing this composition around a 360-degree clockwise rotation (Figure 50) reveals subtle variations in shape, space and colour relationships. Creating three-dimensional work depends on a critical assessment of this movement and specifically the changing visual relationships that are revealed in space.

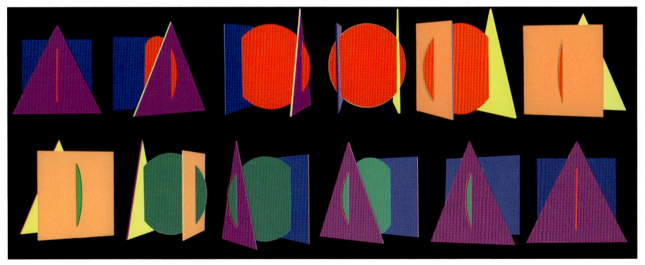

Figure 50 Three geometric shapes in a six-stage rotation, left to right or right to left.

FREE-STANDING FOLDED GEOMETRIC SHAPES IN THREE-DIMENSIONAL ROTATION

Step 3 A single fold on the circle, square and triangle (Figure 51 A) adds a dimension, creating space and shape relationships in three-dimensional composition. The shapes are folded in ways that permit them to stand independently (Figure 51 B), allowing for variety in their placement and organization. Figure 51 B illustrates the same composition in clockwise rotation, showing the shape and space relationships changing from different viewpoints.

Figure 51 A

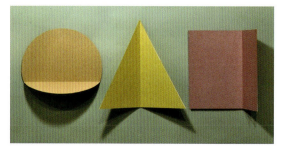

Figure 51 B

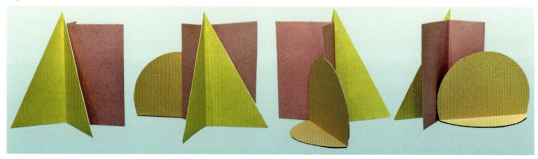

FREE-STANDING FOLDED AND CUT GEOMETRIC SHAPES IN THREE-DIMENSIONAL ROTATION

Step 4 Variety and visual interest can be increased and the development of composition extended through the exploration of simple cuts into the same shapes used above (Figure 52 A). This helps to maintain the coherence of critical assessment and slows development, giving time for reflection and intention. Figure 52 B shows similar shapes in a slightly different orientation.

Important advice
Take your time, keep cuts and folds simple and make the shapes free-standing. This creates a design problem that should be adhered to and solved. There is self-discipline to working in this way, and as a result critical assessment of the work is clearer. This visual dialogue is essential if progress and intention are to be achieved. Work methodically and patiently.

Critical assessment The cuts are simple. The integrity of the original shapes is maintained. There is a complexity in the variety of shape and space relationships. The dialogue between shapes is unified and balanced in composition because the shapes, folds and cuts have retained a geometric context throughout.

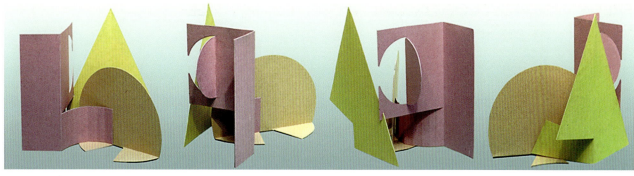

Figure 52 A

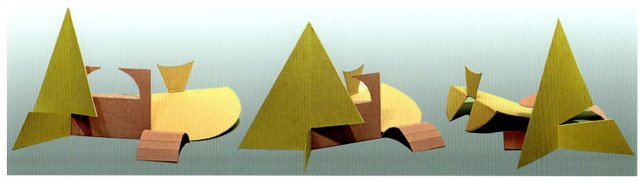

Figure 52 B

FOLDED, CUT, DRAWN LINE, COLOURED GEOMETRIC SHAPES AND LINE IN THREE-DIMENSIONAL ROTATION

Step 5 Cut two geometric shapes out of card or cardboard. Fold and cut them so they are free-standing (Figure 53). Draw line and accent on the cut-out shapes that complement the geometric context. Cut a variety of geometric shapes from coloured paper and glue them to the card. The colour, shape and drawn-line relationships create variety in the composition. You could create a similar composition by using simulated and actual textures on the surface of the card, providing additional elements to explore.

Figure 53

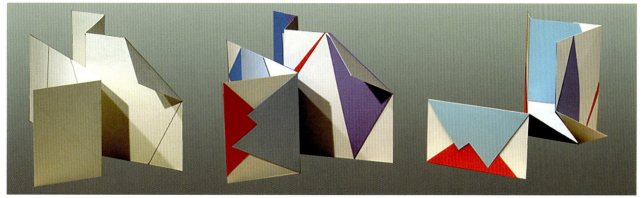

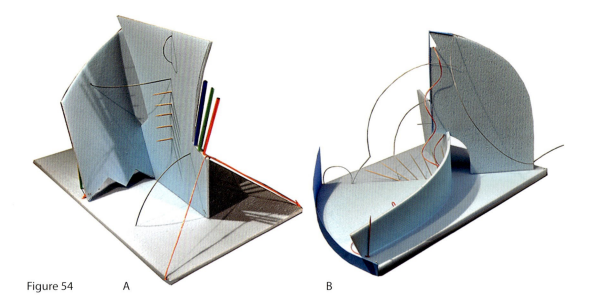

Figure 54 A B

COLOURED GEOMETRIC SHAPES, LINE, ACCENT, ENCLOSED NEGATIVE SHAPE AND SPACE IN THREE-DIMENSIONAL ROTATION

Step 6 The compositions in Figure 54 A and B were constructed using polystyrene sheets with the addition of coloured drinking straws, string, toothpicks and wire to create additional line and colour elements. The wire and string are also effective in creating enclosed spatial relationships and strong negative shapes in space.

NON-REPRESENTATIONAL PERSONAL EXPRESSION USING THREE-DIMENSIONAL FORM

The examples in Figures 55–62 illustrate a variety of approaches to *geometric design* on three-dimensional forms. Some forms are clearly utilitarian (Figures 57 and 58). Others suggest a utility but are primarily decorative (Figures 59 and 60). The objects in Figures 55, 56, 61 and 62 A–C are more in the category of fine art, reflected upon and enjoyed for their aesthetic qualities.

The form of each example has been as thoroughly considered as the applied surface decoration. Each artist made careful decisions regarding their intentions for balancing and unifying form, surface quality and decoration. The decoration on each example is an integral part of the design. Each artist applied their visual language to select visual elements (line, texture, colour, shape, form, light) and place and organize them in harmony with the three-dimensional form. Many of these objects are sculptural, while retaining a suggestion of utility in the intention for the design.

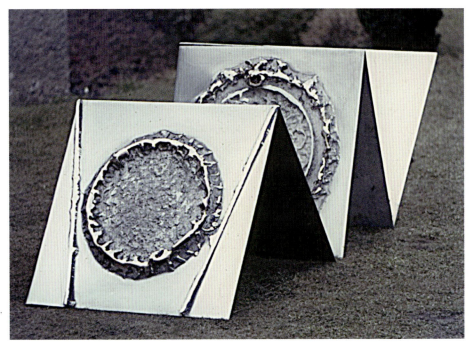

Figures 55, 56
David Cohen, *circa* 1973.
Sand-cast aluminium.
30 x 30 x 90 cm.

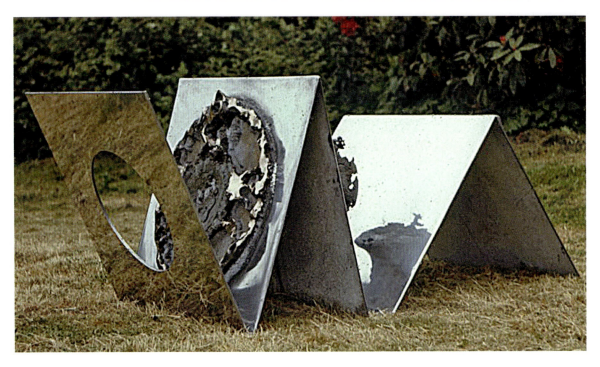

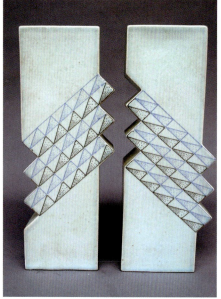
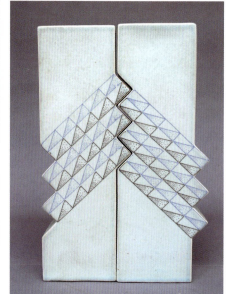

Figure 57 (*left*) Min-Su Park, 1988. Slip-cast ceramic. Oil and vinegar set. 12 x 11 cm.

Figure 58 (*below*) Min-Su Park. Slip-cast ceramic. Salt and pepper set. 9 x 15 cm.

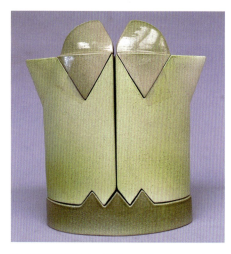
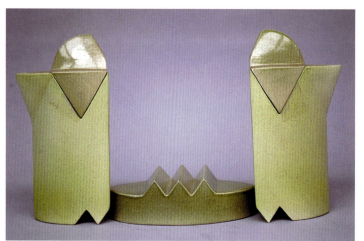
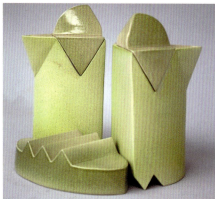
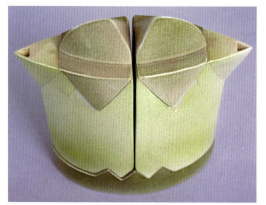

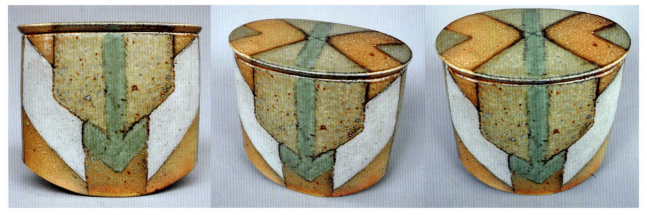

Figure 59 Bente Hansen, 1989. Hand-built stoneware. 14 x 13 cm.

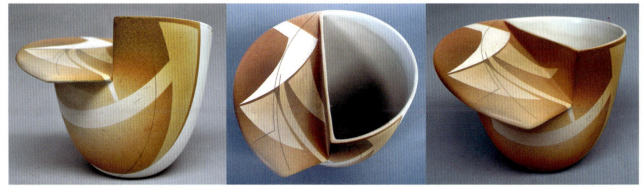

Figure 60 Elaine Dick, *circa* 1995. Slip-cast ceramic bowl. 12 x 17 cm.

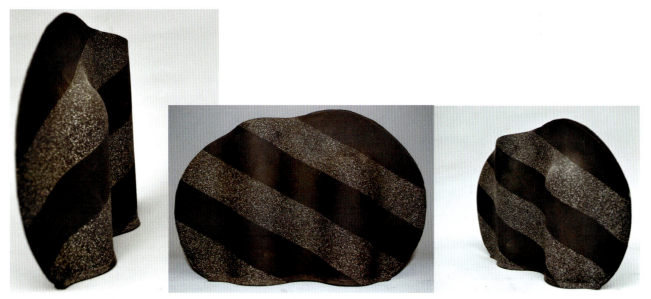

Figure 61 Tony Franks, *circa* 1980. Hand-built ceramic. 26 x 16 cm.

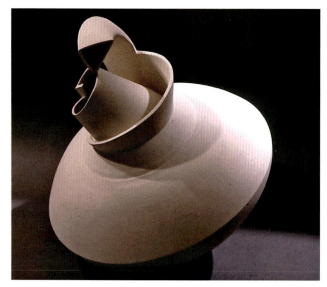
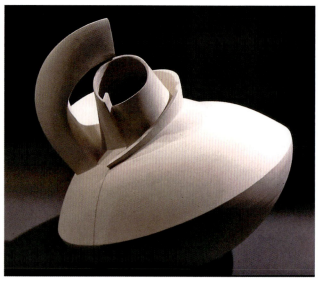

A

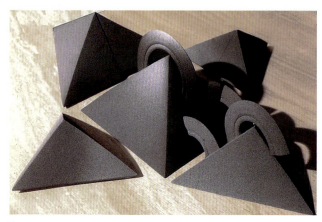

B

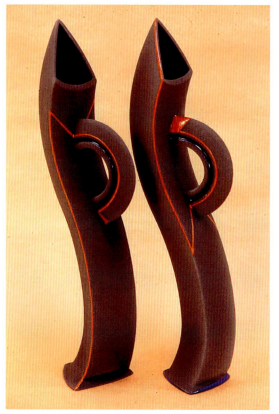

Figure 62 David Cohen:

A Wheel-thrown, extruded and hand-built ceramic. 60 x 60 cm. *circa* 1996.
B Slip-cast and extruded ceramic. Each piece 23 x 23 cm. *circa* 1999.
C Extruded ceramic. 46 x 10 cm. *circa* 2004.

C

3 REPRESENTATIONAL DRAWING AND ABSTRACT ANALYSIS

Before starting it is a good idea to have Figures 2 (Five building blocks to visual language) and 8 (Four key questions) at hand for reference to the essential components of composition.

Figure 63 illustrates this chapter's content from abstract analysis to rendered representational drawing and personal expression.

After completing this chapter you will be able to:

- see subjects and objects using abstract analysis
- draw using one- and two-point perspective
- apply rendering techniques
- apply correct posture when drawing from nature
- see simple still life through abstract analysis
- complete a simple still-life drawing
- appreciate the difference between technique and self-expression.

DEFINING REPRESENTATIONAL DRAWING: PRACTICE MAKES PERFECT

Representational drawing is the ability to draw what you see and render the object or subject with a high degree of 'lifelike' accuracy. This is also a conventional definition of drawing and a misconceived prerequisite for being able to draw in this way is the need to have a special gift or talent.

Learning to draw in a highly representational manner takes patience, time and repetitive practice. It is a skill that anyone with determination, discipline, enthusiasm and the right instruction can learn.

Think about a skill that has a clearly defined and measurable outcome. For example, shooting a free throw in basketball. How long would it take someone to shoot the ball through the hoop ten times in a row from the marked free throw line? This depends on a number of factors: the individual's previous experience, the quality of instruction they receive, their determination and the opportunity to practise consistently. With all of these in place for an infinite amount of time, eventually the goal of ten out of ten could be achieved. Does the development of this specific skill and achievement of this goal make a great basketball player? No – just as the skill of being able to render a lifelike drawing does not make a great or especially talented artist.

A beautifully rendered representational drawing may be impressive to the unskilled layperson; however, demonstrating a refined and well-executed observational skill does not always result in self-expression.

A more accurate definition of representational drawing is best placed within an academic and observational framework. There are necessary reasons for practising this skill: representational drawing can dramatically improve the ability to see, evaluate and apply visual elements in composition. The need to draw in this way continues to play a vital role in the development of visual vocabulary. It is one of many necessary skills that will lead to greater visual literacy.

Figure 63 REPRESENTATIONAL DRAWING

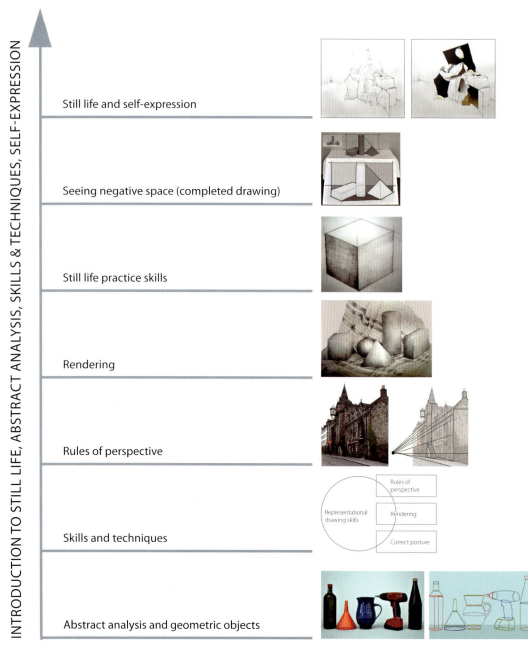

INTRODUCTION TO STILL LIFE, ABSTRACT ANALYSIS, SKILLS & TECHNIQUES, SELF-EXPRESSION

Still life and self-expression

Seeing negative space (completed drawing)

Still life practice skills

Rendering

Rules of perspective

Skills and techniques

Abstract analysis and geometric objects

DEFINING ABSTRACT ANALYSIS: SEEING GEOMETRIC FORM

Chapters 1 and 2 introduced geometric shapes in two- and three-dimensional, non-representational compositions. Non-representational approaches allow for freedom in decision-making when selecting visual elements for their own sake to create composition. Intention is realized through aesthetic and design decisions that result in organization, balance, unity and variety. The eye is not required to see beyond the boundaries of the drawing paper or three-dimensional structure.

In this chapter the context shifts to representational composition (drawing actual subjects and objects in the world). To draw in an abstract or non-representational manner is not the goal here, so liberties are somewhat restricted. The challenge presented in representational drawing lies in the achievement of accurate interpretations.

Selection is most important because the world is visually stimulating. Only through acute selection can any visual sense be made when drawing in a representational manner.

Representational drawing is a skilled discipline. The goal is to convince the viewer that your interpretation and visual assessment of the three-dimensional object(s) and/or subject(s) being observed are accurately transferred to the drawing paper.

The accuracy of this interpretation and assessment depends on the ability to see geometric shapes in existing three-dimensional forms (Figure 64).

If you can see form as geometric shape you will be able to accurately set up the objects you are drawing in your composition. Abstract analysis achieves this geometric set-up.

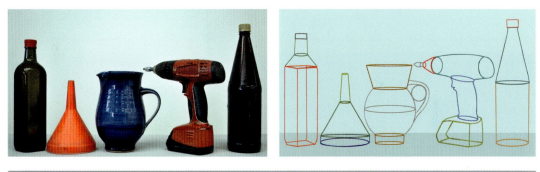

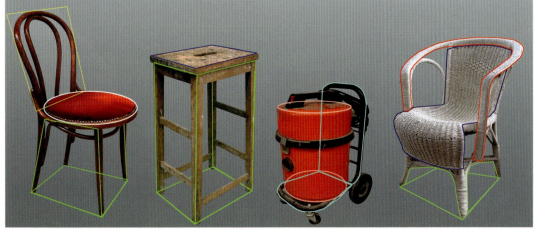

Figure 64

Examples of simple objects that have a geometric structure are illustrated in Figure 64. To be able to draw objects accurately it is important to see lines, spheres, ellipses, cylinders, cubes, cuboids, and cones inherent in the structure. Abstract analysis is a necessary first step to be able to draw the objects on paper before any rendering takes place.

MAKING VISUAL SENSE OF THE WORLD

Drawing from nature presents visual challenges in accurately seeing and discriminating between the complex varieties of competing visual elements.

The photograph of the garden in Figure 65 A illustrates visual complexity: the 'reality' of the scene. Every little detail: colours, textures, lines, values, and shapes have been captured and represented. The drawing in B is an interpretation of reality. Drawing is expression, created by the maker's skill and application of visual language to select what they wanted the composition to communicate, based on their intention.

Figure 67 Illustrates what Cohen was seeing and thinking about when drawing Figure 65 B, and how he applied his critical assessment to achieve his intentions for the composition.

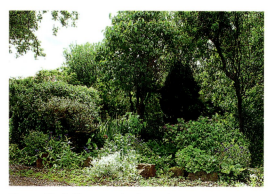

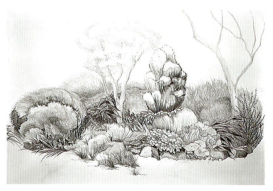

Figure 65 A Photograph of a garden scene.

B Drawing of the same garden scene. David Cohen, 2011. Pencil on paper. 92 X 60 cm.

SKILLS AND TECHNIQUES

Cohen's garden drawing (Figure 65 B) demonstrates highly skilled techniques. Anyone can master skills and techniques with consistent practice and dedication to the task. Figure 66 highlights essential skills and techniques that need to be practised and understood in order to achieve convincing representational drawing.

Skill and technique alone will never result in finding deeper expression in your artwork. However, they are important (combined with seeing, intention, selection and critical assessment) towards this eventual goal.

Figure 66

Figure 67

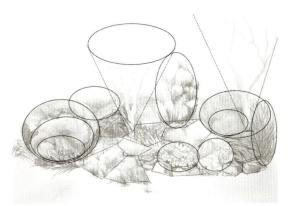

ABSTRACT ANALYSIS

During the initial set-up of the composition, the trees, bushes, plants and rocks are seen as very simple geometric forms, with no detail or rendering. This helps to establish selection, placement and scale within the frame of the paper.

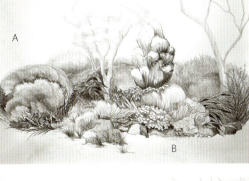

SELECTION

Drawing from nature requires a great deal of selectivity. Decisions about what to include and what to leave out (A & B are areas that have been deliberately left out) will determine the composition and make the drawing a reflection of your self-expression. Selection determines intention. In this drawing selection is clearly expressed through the horizontal rhythm and variety of textures. This is what is seen and experienced by the viewer.

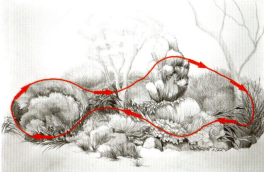

INTENTION

The balance and organization of verticals and horizontals blend with light and dark values. The variety of textures are carefully balanced and controlled against one another. Skilled rendering techniques make this illusion convincing, and distinct. This creates visual flow in the composition (illustrated by the line and arrows).

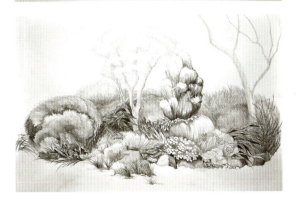

COMPOSITION

The finished composition is the unique visual expression of the maker and their ability to apply abstract analysis, selection and intention. This is a deeply critical and thoughtful process that takes many hours of dedicated practice. The placement and organization of line, shape, value, texture, scale, and light are all balanced in a unified way that ultimately demonstrates the individual style of the maker.

RULES OF PERSPECTIVE: THE ILLUSION OF SPACE, SCALE AND DEPTH

In preparation for representational drawing it is important to learn and practise some simple rules governing perspective.

These rules help to see and interpret the dimensional world for the purpose of accurately drawing the illusion of scale.

The accuracy of this illusion visually describes objects that appear to vary in scale depending on the spatial relationships that exist. Simply put, objects that are nearer appear larger than objects that are further away.

For example, in Figure 68 the telegraph pole nearest the viewer's eye appears much larger than the poles in the distance. In reality they are approximately the same size. The distance between the poles creates perspective; the illusion that the poles appear to be different heights. So how is this illusion drawn? The following exercises illustrate simple steps to achieving this.

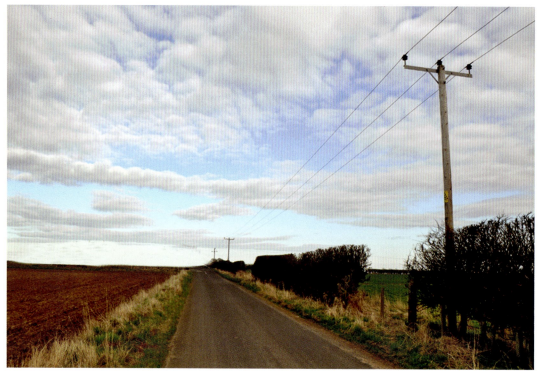

Figure 68

EXERCISE 1: How to create the illusion of flat non-representational space – establish the horizon

Placing simple geometric shapes on a piece of paper, in line with each other (Figure 69 A) creates no space or depth; everything in the picture plane remains flat. By creating two background shapes of different colours (Figure 69 B, 1 and 2), a horizon line is established. Placing the cut-out shapes on the line introduces a sense of space. There appears to be a foreground and a background space, but no depth.

Creating space between the shapes and placing them below the horizon line (C) creates the illusion of depth. Changing the scale of the shapes (D) creates dramatic spatial relationships, and a strong illusion of depth perspective. Introducing more coloured shapes and varying the scale, extends the spatial play (E).

The possibilities for experimentation and introducing more visual elements such as tone, texture and line are now possible.

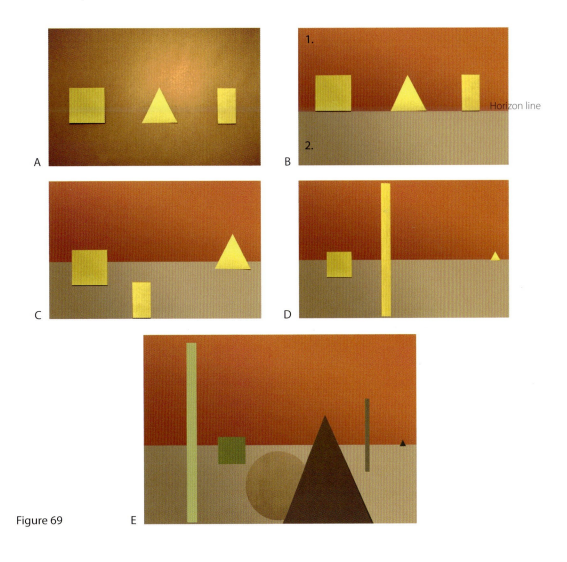

Figure 69

EXERCISE 2: How to create the illusion of dimension in non-representational space – establish the horizon in one-point perspective

The previous examples introduced the principal of establishing a horizon line to enable a visual play in space using flat shapes. The following examples demonstrate a similar starting point using shapes that show more than one side. The shapes conform to the rules of one-point perspective (a single vanishing point on the horizon line).

Using a pencil and a ruler, draw a horizon line and mark one point on the horizon. This point is where all lines recede to and eventually vanish, hence the name 'vanishing point' (Figure 70 A).

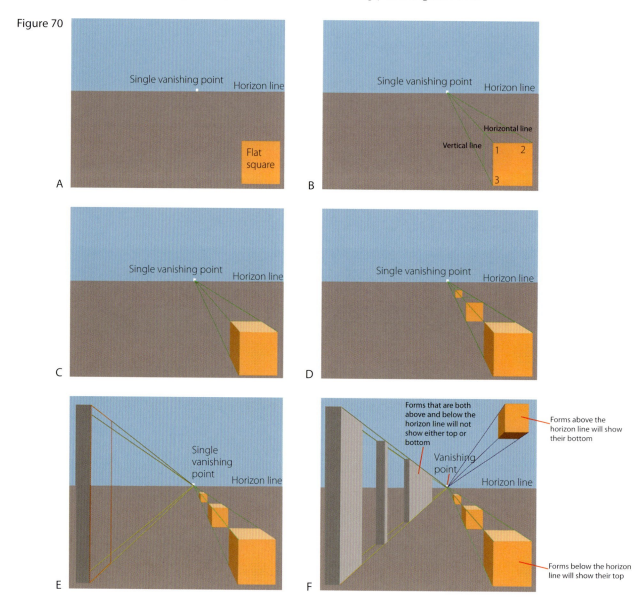

Figure 70

Figure 70 A–F demonstrates one-point perspective using cubes and cuboids. In Figure 70 A, a cube is drawn as a flat square; the horizon and vanishing point are also established. In B the corners of the square (1, 2 and 3) are drawn back to the vanishing point. With the addition of vertical and horizontal lines, dimensions of the cube begin to take shape. Values (C) are added to make the illusion convincing. Multiple cubes can be added following the same principles (D).

Different geometric shapes can be added in various locations above and below the horizon line. The illusion of perspective will be successful as long as lines defining the dimension of the cube are drawn vertical, horizontal and lead back to the vanishing point (E and F).

EXERCISE 3: How to create the illusion of dimension in actual exterior space – establish the horizon in one-point perspective

The photograph in Figure 71 A shows an actual space and objects in that space. By applying abstract analysis (B), the objects are drawn as simple geometric shapes: the hedgerow, road, fields, telegraph poles, and grass verges get reduced to simple geometric shapes and lines (triangles, cylinders, rectangular boxes, lines). This is abstract analysis. Practise seeing shapes and lines in nature, then follow rules of perspective to draw convincing illusions of space, scale and depth. Detailed rendering, textures, values and colours can be drawn later after an accurate set-up using simple abstract shapes is achieved.

Figure 71

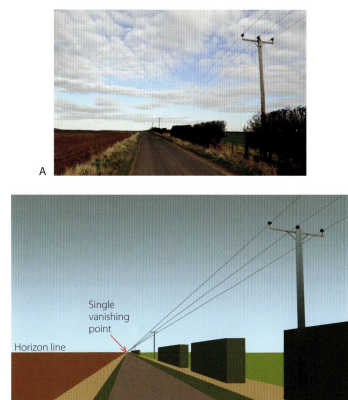

A

B

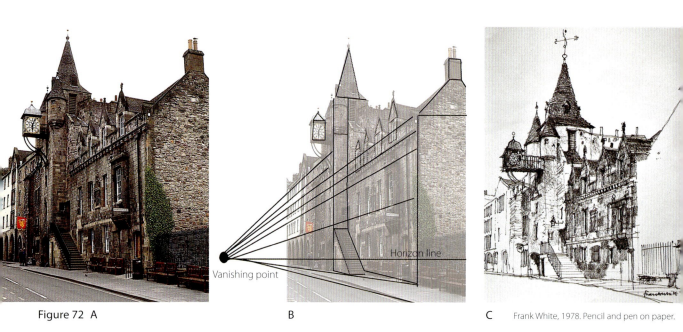

Figure 72 A B C Frank White, 1978. Pencil and pen on paper.

The exterior building (Figure 72 A) illustrates the original subject being drawn. One-point perspective, abstract analysis (B) and White's rendered drawing (C) demonstrate his selection, intention and self-expression. Appreciate that some areas of the drawing are rendered more than others to create focal point and balance in the drawing.

EXERCISE 4: How to create the illusion of dimension in interior space – establish the horizon in one-point perspective

In Figure 73 C the horizon is not visible. The rule is that the horizon line always exists at eye level, whether the viewer is standing, sitting or lying down, or whether it is visible or not.

Always begin by establishing the horizon line and the vanishing point. The single vanishing point is always directly in front of the viewer's body and at eye level on the horizon line.

Drawing set-up
In Figure 73 A, after the horizon line and vanishing point are established, apply abstract analysis to draw the basic shapes that will comprise the room. Begin with the rectangle shape of the wall directly in front. Draw the connecting lines where the ceiling meets the side walls and the floor meets the side walls.

B The empty interior space is now accurately established, made more visible by adding different colours to each shape.

The actual subject

C The remaining objects in the room (tables, chairs, windows etc.) can now be drawn as simple geometric shapes, following one-point perspective (D). Be selective when deciding what objects to include and leave out. Decide on the composition based on the intention for the drawing.

Once the drawing is accurately set up, selective rendering will complete the composition.

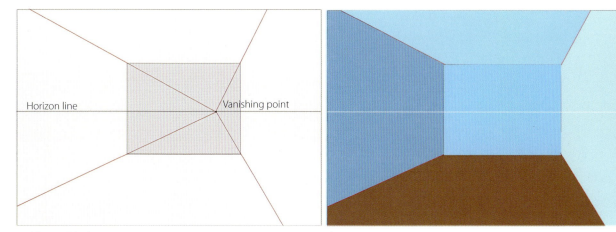

Horizon line · Vanishing point

Figure 73 A

B

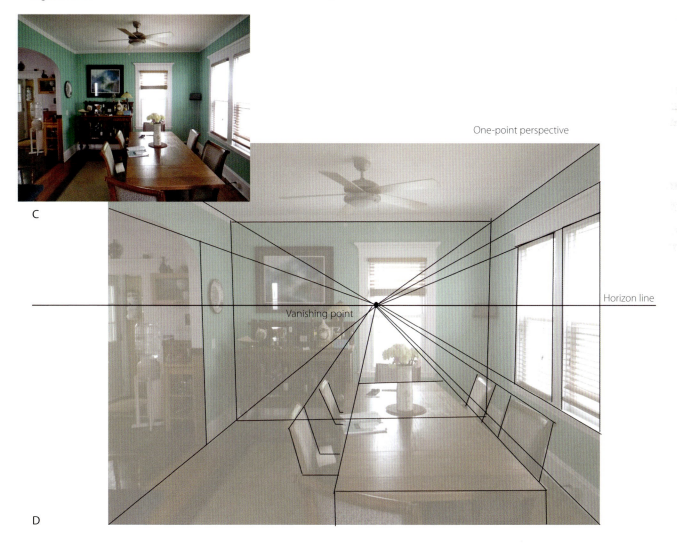

C

One-point perspective

Vanishing point · Horizon line

D

EXERCISE 5: How to create the illusion of dimension in exterior space – establish the horizon in two-point perspective

Two-point perspective is used when two sets of parallel lines recede to two vanishing points in opposite directions (Figure 74 A). For example this is common when standing at the corner of a building and seeing two side walls of the building at the same time, receding in opposite directions (B).

The same principles of one-point perspective apply when establishing the horizon line at eye level. However, in two-point perspective there are two vanishing points, on the horizon to which the parallel lines of each side wall recede.

It is important to keep lines vertical and parallel to achieve an accurate illusion of space and scale.

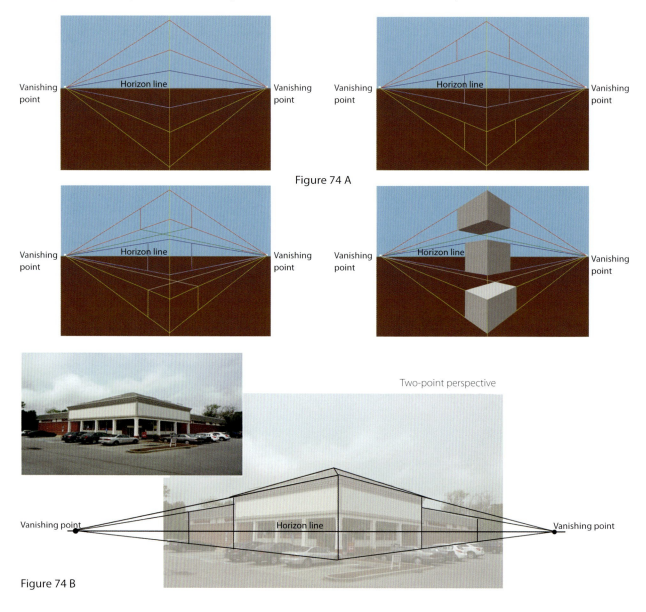

Figure 74 A

Figure 74 B

Two-point perspective

Perspective, interior space and personal expression

The drawings in Figure 75 developed from observing the interior space in A. They evolved in sequence (B–H), starting with a simple representational pen and line drawing (B). In C, selection appears in the decision to accent shapes to give the drawing greater depth.

The introduction of colour and the variation in composition move the series towards personalized, abstract and unique conclusions (G and H). These conclusions were influenced by Henri Matisse (1869–1954) and Thomas Wesselmann (1931–2004), two painters who created abstract impressions of interior spaces, using strong shapes and vibrant colour.

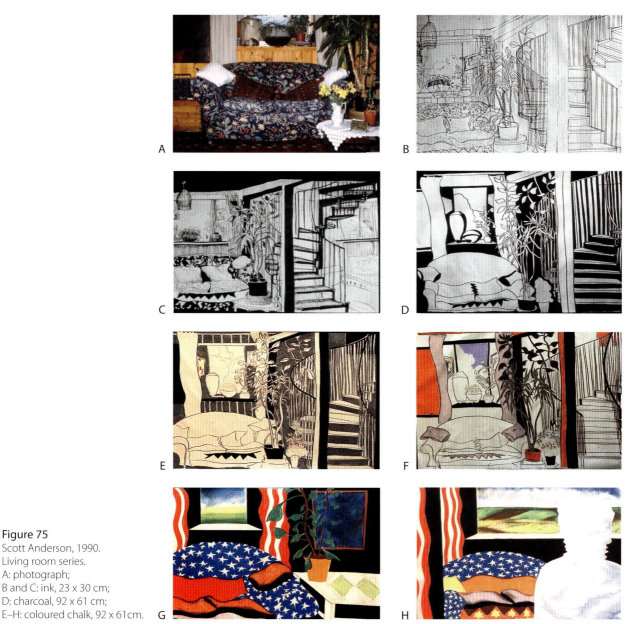

Figure 75
Scott Anderson, 1990.
Living room series.
A: photograph;
B and C: ink, 23 x 30 cm;
D: charcoal, 92 x 61 cm;
E–H: coloured chalk, 92 x 61cm.

EXERCISE 6: Rendering – drawing as interpretation and illusion

Rendering is applied to interpret an illusion of light, value, dimensional space and form. An accurate representational drawing (Figure 76) requires selection, practice and rendering skills, such as hatching and cross-hatching (Figure 78) to achieve a convincing illusion.

Rendering helps to understand which pencil to use to achieve light and dark values (Figure 77).

Practice skill: hatching and cross hatching using an HB (#2) pencil.

Figure 76

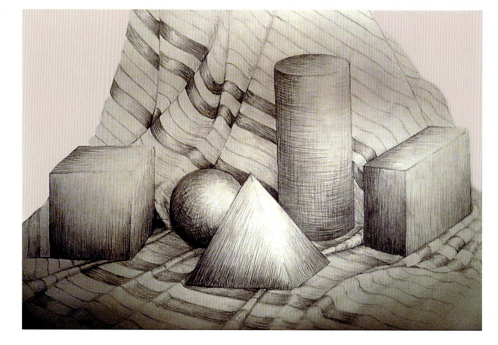

Figure 77 The range of pencil values on a continuum.	8H	6H	4H	2H	H	F	HB	B	2B	4B	6B	8B
	Harder graphite Lighter value						Medium		Softer graphite Darker value			

Figure 78

Hatching: diagonal lines in one direction. The closer together the lines and the greater the pressure applied with the pencil, the darker the value.

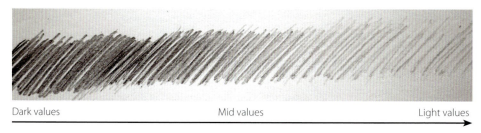

Dark values Mid values Light values

Cross-hatching: diagonal lines crossing in opposite directions. The closer together the lines and the greater the pressure applied with the pencil, the darker the value.

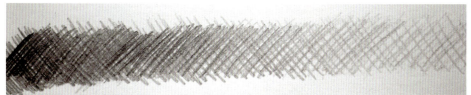

Hatching and cross-hatching applied

Perfecting rendering technique using any drawing material (pencil, charcoal, crayon, pastel) takes many hours to achieve. A great deal of practice is needed to learn to control and visually describe form, values, textures, shape and line. Selection, organization and placement will also determine the quality of the drawing and composition. Be patient and take time. Figure 79 was completed in fifteen hours over three days.

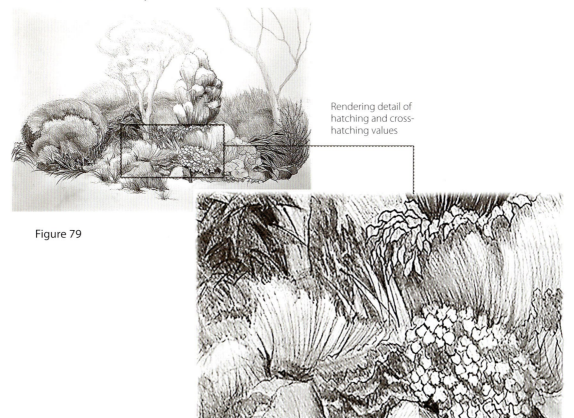

Rendering detail of hatching and cross-hatching values

Figure 79

EXERCISE 7: Correct posture

Before drawing, make sure drawing posture is correct. Adopt a sitting position and make sure the eyes are seeing the drawing paper on its board or easel and the objects to be drawn at the same time. This is achieved using primary vision (eyes on the object or subject) and secondary vision (eyes on the drawing paper) simultaneously.

With the drawing board tilted up at an angle, both the drawing arm and the hand holding the pencil are free to move (Figure 80 A). The head does not move, only the eyes and drawing arm. This helps concentration and relaxation, with undivided attention on seeing the objects and applying the necessary skills. The drawing arm needs to work freely in this position. Free and loose arm movement will make the drawing. The hand lightly holds the pencil in place as the arm moves freely around the drawing paper in relationship and in coordination with the eyes seeing visual information for continuous assessment. This coordination takes practice.

A poor drawing position and posture (Figure 80 B) will compromise the ability to use both primary and secondary vision. Interrupted or obstructed sight will cause undue stress and diminish the visual information being translated through mind, eye, hand and arm. Arm movement is restricted. Concentration and sight will be disrupted, causing frustration, and discomfort, impeding skill and development.

Figure 80 A

B

EXERCISE 8: An introduction to still life – getting started – applying abstract analysis

In Chapters 1 and 2 the square, circle, and triangle were introduced as simple, flat shapes (Figure 81). To retain coherence the same shapes are used to introduce still-life drawing.

Figure 81

| Square | Triangle | Circle | Rectangle |

Figure 82

A Geometrically shaped objects purchased from a shop **B** The same objects painted grey

Simple flat shapes: no rendered value or dimensional form

Undecorated, simple geometric shapes are arranged in a group so they can be drawn accurately and convincingly. After this is achieved, higher-level skills of self-expression and style are explored. Simple three-dimensional shapes can be purchased inexpensively (Figure 82 A). Paint the objects grey or white (Figure 82 B), so there are no graphics or patterns to distract the eye from assessment of form.

When drawing objects in a representational manner, visual interpretation and expression of form and dimension are achieved by rendering. Three-dimensional illusion is made convincing by identifying the light source, and rendering light, mid and dark values on the surface of the shapes (Figure 83).

Figure 83

| Cube | Pyramid | Cuboid | Sphere | Cylinder |

Rules of perspective and foreshortening (the illusion that the object or the distance between the objects appear shorter than they actually are) need to be considered. These 'tricks of the eye' need to be interpreted to draw form convincingly.

To be able to draw objects, abstract analysis must be applied. To help you do this, ask yourself: 'What do I see?' before you begin to draw.

HOW TO APPLY ABSTRACT ANALYSIS: THE CUBE

For the purpose of drawing, knowing the name 'cube' is of little use. There is nothing in the name of an object that will help to see the object or draw it accurately and convincingly in a representational manner.

Stop naming objects and practise seeing them and describing their form using visual elements and applying abstract analysis. This is visual thinking and a very helpful way to see.

Seeing objects requires a critical, abstract analysis of form. Practise seeing the cube in abstract terms to reveal abstract information. For example, an accurate abstract response to the question 'What do I see?' in relation to a cube:

I see a cube that has:

• six squares of equal proportion

• vertical and horizontal lines

• lines parallel to each other.

Abstract analysis reveals 'abstract information', critical to be able to see and therefore draw the cube in a representational and convincing manner. Seeing this information in the object means that with practice it can be accurately applied in drawing. The word 'cube' is never mentioned.

DRAWING ONE OBJECT AT A TIME: PRACTICE 'SET-UP'

Practice skills: Before drawing still-life objects in a group, practise drawing them individually. There is little point in starting to draw multiple objects when there is no visual understanding of individual objects. Do not be concerned with the surface the object is sitting on, simply concentrate on the object itself; become familiar with form, dimension and the scale of each shape. The familiarity that comes with repetitive practice helps you to see the objects more accurately.

Before any rendering of light, value and form, the cube (Figure 84, Cube 1) must be drawn in correct 'set-up' (Steps 1–5) on the paper. Follow these five steps to practise the cube drawing 'set-up'.

Setting up the drawing involves evaluating the correct proportion (scale) and the angle at which the cube is sitting. It is a little less challenging to place the cube in a position where three planes are visible (two sides and the top).

Step 1 Draw the vertical line A. This line appears closest.

Establish the correct angle the cube is sitting at (lines B and C). Once lines A, B and C are drawn accurately, all remaining vertical lines (**Step 2** D–E) and all diagonal lines (**Step 3** F–G; **Step 4** H–I) are parallel to each other.

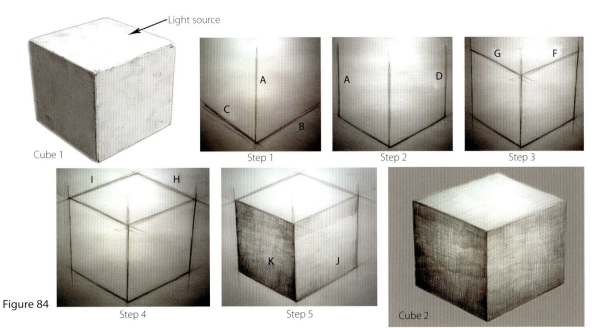

Figure 84

Cube 1

Step 1

Step 2

Step 3

Step 4

Step 5

Cube 2

Step 5 Rendering the cube to illustrate light, mid and dark values that describe the illusion of form and light source. Cube 2 illustrates the completed, fully rendered drawing of the cube in an accurate and convincing manner.

There are common errors (Figure 85 A and B) when drawing this object for the first time. In Figure 85 A the maker has failed to draw a vertical line (1) and in B the lines (2) are not parallel so the cube is inaccurate and unconvincing. A helpful technique is to use the edge of the drawing paper as a visual guide to help establish a vertical line (A).

In Figure 85 A and B, the intention for a convincing drawing has not been achieved, so the maker must have the discipline to see errors in observation and repeat the drawing as many times as necessary until the object is correct and convincing.

Vertical edge of drawing paper as a visual guide

Vertical line

1.

2.

Figure 85

A

B

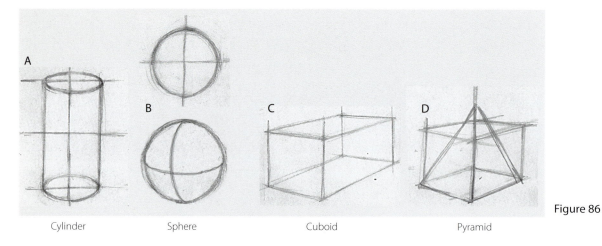

| Cylinder | Sphere | Cuboid | Pyramid |

Figure 86

SETTING UP OTHER GEOMETRIC SHAPES

It is a good idea to draw the set-up of shapes as if they were made of glass (Figure 86). Drawing all the lines, whether they are visible or not, helps to establish correct proportion.

The cuboid (Figure 86 C) is drawn using the same steps as the cube. Care should be taken to evaluate any foreshortening (subtle perspective) with this particular object because its length can appear greater than it actually is.

The cylinder (Figure 86 A) and sphere (B) are symmetrical. Regardless of where they are viewed from, their shape remains constant. Careful rendering will create the illusion of volume and form.

The pyramid is a challenging shape to draw. A technique that can be tried is to draw the base of a cube, then a vertical line through its centre. From the corners of the base of the cube, draw lines to meet the vertical line, in proportion to the scale of the pyramid.

STILL-LIFE GROUP 'SET-UP': ABSTRACT ANALYSIS USING GEOMETRIC SHAPES

After drawing each object individually, arrange the objects on a table in a group (Figure 87).

See everything as simple geometric shapes. The rectangular shape of the drawing paper provides a picture frame (represented by the yellow line rectangle in A) within which to assess accurate proportion, dimension and scale of the objects and how they will fit on the paper. Do not draw the objects smaller than they appear in reality. Make sure the objects are represented in a balanced and organized way so that they 'fill' the frame but never extend beyond the edges.

In Figure 87 A the yellow rectangle indicates visual assessment of the drawing paper in relation to the scale of the objects and their position on the table and how they will fit on the paper. The 'cross' lines represent the horizontal back edge of the table and the vertical line of the cylinder. This immediately establishes a clear and accurate starting point of visual reference to be able to set up the drawing.

The scale and position of the cylinder (Figure 87 B) can be accurately drawn with confidence. There is no perspective or foreshortening with this symmetrical shape: it appears flat until rendered.

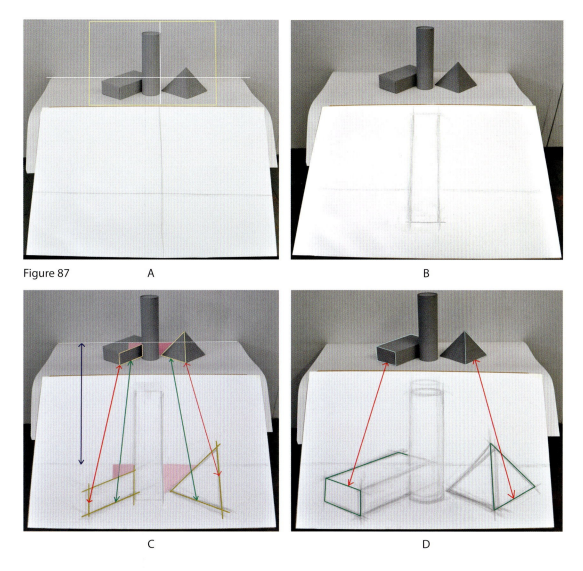

Figure 87 A B

C D

The other positive shapes (pyramid and rectangular box) can now be drawn using light lines (C and D). Never be tempted to render objects until all the shapes in the composition are set up accurately and convincingly. Time and energy can be wasted by rendering one object, only to realize that the set-up of the remaining objects is inaccurate.

The coloured arrows (Figure 87 C and D) correspond to specific shapes translated accurately to the drawing paper. The set-up may take several practice attempts to achieve an accurate drawing. It will take great patience and determination to achieve the necessary outcome. The eye must be trained to see. This is the fundamental purpose of practising representational drawing and drawing the life figure (Chapter 4) in an academic, disciplined manner.

THE IMPORTANCE OF NEGATIVE SHAPE: APPLYING ABSTRACT ANALYSIS IN THE SET-UP

The negative shapes (Figure 88 C in grey) between the positive objects (A) are very important. These are the 'invisible' lines and shapes (B) that you need to see and draw in the set-up. Accurate negative shape analysis and accurate positive shape assessment = convincing drawing and abstract analysis.

Figure 88

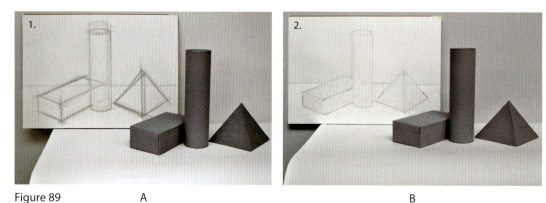

RENDERING THE DRAWING: AFTER ABSTRACT ANALYSIS AND SET-UP

After the objects have been accurately and convincingly set up, erase all additional lines (see the difference between the drawing in Figure 89 A and the clearer lines in B). What is left is a single light pencil line that describes the outline of each object. The rendering of the objects (C and D) will take many hours of patience, control and practice, together with careful selection and intention.

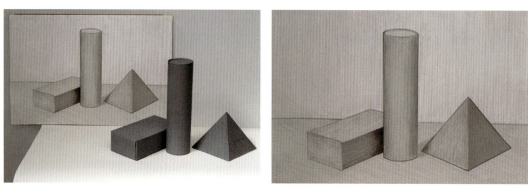

Figure 89 A B

C D

SELF-EXPRESSION AND STILL LIFE

Beyond technical competence and skill acquisition is self-expression. This is a higher-level outcome that takes deep desire, confidence and initiative to develop. (Chapter 5 explores self-expression in depth.)

This chapter presents examples of still life as a subject for self-expression. Selected artists express style and intention, making their work original and the highest quality.

Selecting still-life objects to draw

Still life, figure drawing, landscape and self-portraiture have been enduring subjects of artistic expression. They present the artist with timeless visual challenges, approached in wonderful and unique ways.

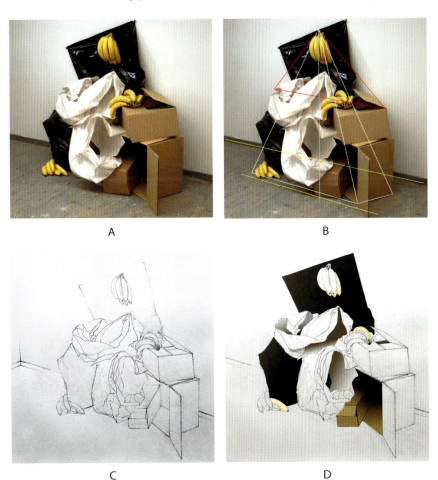

A

B

C

D

In Figure 90 A, David Cohen carefully selected objects and composed them in a manner that reflected his intention for his drawing (Figure 90 B and C). Placing and organizing objects for still-life study is never done arbitrarily. Composition for the drawing begins in the arrangement of the objects in an interesting visual relationship.

The objects are placed loosely and informally in relation to each other. Objects high in contrast (fruit, plastic, paper and cardboard) were deliberately selected so that Cohen had a variety of visual options to select from when drawing. Each object has contrasting elements to be explored: texture, colour, shape, line and scale.

Cohen created balance and rhythm in the arrangement and placement of objects, highlighted by the coloured lines in the abstract analysis (B). The pyramids and triangular invisibles (made visible by the coloured lines) establish the overall shape of the composition; within which the contrasting objects were placed.

Figure 90
David Cohen, 2011. Pencil and mixed media on paper.

The drawing set-up (C) is established. Appreciate that no rendering is applied before abstract analysis and set-up are complete. Intention and selection will determine rendering, and focal point to complete the composition (D). See how careful selection regarding what will and what will not be rendered results in visual variety and movement in the composition. The composition is balanced and organized, with a highly stylized and unique approach.

Jack Knox

In this series (Figure 91 A–C) the painter Jack Knox demonstrates his self-expression in a series of compositions based on the still-life theme. Knox's highly stylized approaches express forms, textures and colours. The basket and fruit in A and B are expressed in a representational manner and in a way that explores and expresses abstract qualities in his interpretation and intention. C is an abstract approach to fruit forms and colours, in high contrast to the basket texture. Although the artist's chosen medium is paint, he clearly has a deep understanding, knowledge and appreciation of form and structure in his subject, achieved through many preparatory sketches and drawings. Drawing always plays a critical role in realizing his intentions.

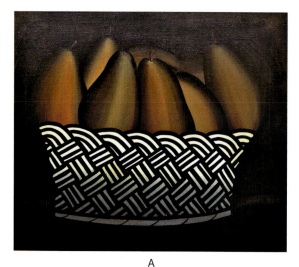

A

Figure 91 Jack Knox.

A *'Eight Pears in a Basket'*, 1972. PVA on canvas, 55 x 60 cm. Collection of David Cohen and Frances Gardiner Cohen.

B *'Big Basket of Pears with Shadow'*, 1973. PVA and graphite on canvas, 122 x 102 cm.

C *'Big Fruit Basket', circa* 1974. PVA on canvas, 126 x 127 cm.

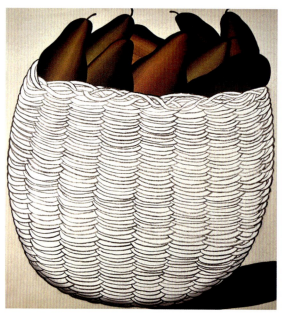

B

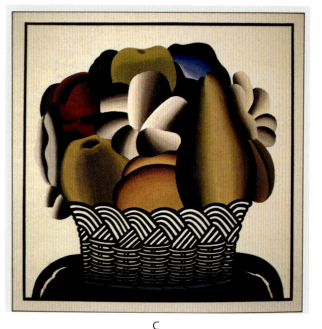

C

David Cohen

David Cohen is passionate about nature and the fruit form in his ceramic art. In the examples in Figure 92, he has also explored the 'fruit in a basket' theme on the surface of a slip-cast plate (A) in an abstract manner and in a three-dimensional, representational approach, using a bottle form (B).

Knox and Cohen are interested in similar themes but have used their visual language to investigate and realize their intentions, having mastered their chosen mediums to create unique expression. Their visual language is mature, and they are confident in their ability to make visual statements that can be recognized as their own. They understand their approaches in the context of art history and use this history, among other references, as points of influence, but never copy. In this regard their work is their conclusion, never a starting point.

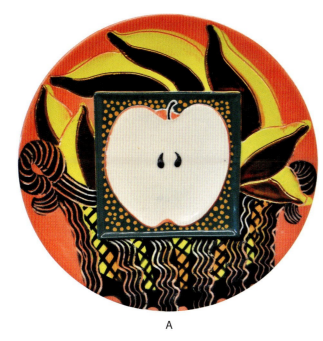

A

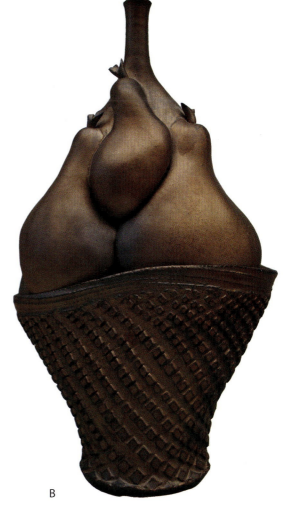

B

Figure 92 David Cohen
A Slip-cast plate. 29 cm diameter.
B Thrown and hand-built vase. 38 cm high.

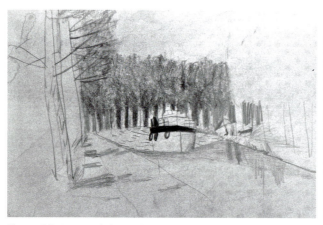

Figure 93 Artist and date unknown. Pencil on paper. Collection of David Cohen and Frances Gardiner Cohen.

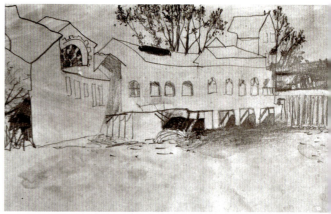

Figure 94 Artist and date unknown. Pencil on paper. Collection of David Cohen and Frances Gardiner Cohen.

SELF-EXPRESSION AND REPRESENTATIONAL DRAWING

The drawings in Figures 93–97 show great skill, technique and individual approaches to expressing themes, objects and subjects each artist was observing. Figures 93 and 94 are simple rendered studies. They do not conform to a 'photographic' realism of the scenes – this was not the artist's intention. It is important to see the acute selection of what is rendered and what is not. The artist creates focus, balance, and depth with highly selective and sensitive rendering. They are not completely accurate in following rules of perspective, but are close enough to make the scenes convincing and full of character.

John Busby

John Busby (Figure 95) is a master at capturing the character, beauty and essence of wildlife scenes in his drawings and paintings, in particular the life of seabirds. Busby's intention in this drawing is clear. He steers the viewer's eye diagonally through the composition, following the line of birds perched along the edge of the cliff top. Busby creates this visual movement by rendering darker values on carefully selected birds and rocks along the cliff edge. These accents create focal points and visual movement. The remaining areas in the drawing are very lightly rendered, creating contrast and variety with the simple suggestion of texture, line and shape.

Liz Ogilvie

These drawings by Liz Ogilvie (Figures 96 and 97) are masterfully rendered seascapes with a highly representational quality. This creates mood and atmosphere for the viewer. You can feel the sea crashing ashore as you view these drawings. They capture a moment in time and yet the fluidity and movement that are expressed create a scene that seems to be always changing, like the ocean itself. The power of the sea is communicated and the viewer can see and feel it in the energy of the rendering. The composition in Figure 96 is a little more abstract, with the border surrounding the detailed scene. This has the effect of steering the viewer's attention to the centre of the drawing, creating a strong focal point in the composition.

Figure 95 John Busby, 1985. Pencil on paper. Collection of David Cohen and Frances Gardiner Cohen.

Figure 96 and **97**
Liz Ogilvie, 1972. Pencil on paper. Collection of David Cohen and Frances Gardiner Cohen.

4 THE FIGURE

ABSTRACT ANALYSIS AND THE FIGURE: SIGNIFICANCE AND VALUE

Academic life drawing requires us to see the physical attributes of the human form. An understanding of the muscular and skeletal structures helps to draw the figure convincingly, and to assess subtle complexities of form, proportion and scale. Abstract analysis can identify visual elements in the set-up of the drawing and establish a foundation for composition.

Life drawing (two dimensions) and life modelling (three dimensions) present many visual challenges. The question is: What is the value and relationship of these disciplines to developing visual literacy and personal expression?

Life drawing and life modelling have always been a part of traditional academic frameworks where the study of the human figure is regarded as an essential and integral part of learning to see for the purpose of artistic expression, across visual disciplines.

Traditional approaches use the figure as a primary source for learning to apply visual vocabulary. The student learns to recognize, select, apply and evaluate visual elements and composition. Rigorous drawing study demands regular practice. Appreciating expressive approaches to the figure in art history can also provide important references to support practice.

Changes in art education today reflect changes in art practice and the place of art in society. Figure drawing is given more or less priority depending on the teaching philosophies of educational institutions. The constant is that visual language remains critical to all forms of visual communication. In this context, the study of the figure as an academic subject does have contemporary relevance.

Excellent examples of life drawing continue to be an essential component in student portfolios and as a subject for study, figure drawing can contribute greatly to advancing visual literacy across disciplines. Figure 98 illustrates how this chapter explores life drawing through an academic approach and also provides contemporary examples of how the figure is referenced by artists for personal expression.

After completing this chapter you will be able to:

* appreciate the value of drawing the life figure in an academic way
* see the figure by applying abstract analysis
* see the character of the pose
* appreciate the importance of intention and composition by rendering/not rendering
* appreciate the use of the figure as a subject for self-expression
* draw a self-portrait.

Figure 98

LIFE DRAWING & SELF-PORTRAIT

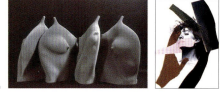

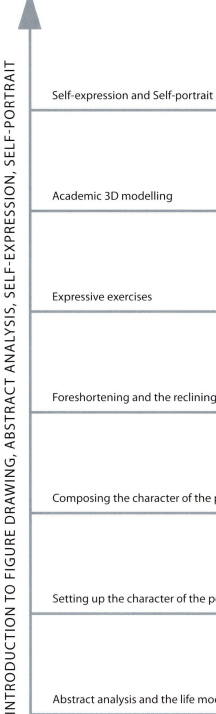

Self-expression and Self-portrait

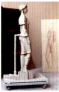

Academic 3D modelling

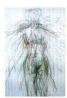

Expressive exercises

Foreshortening and the reclining pose

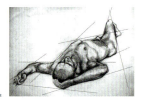

Composing the character of the pose

Setting up the character of the pose

Abstract analysis and the life model

INTRODUCTION TO FIGURE DRAWING, ABSTRACT ANALYSIS, SELF-EXPRESSION, SELF-PORTRAIT

WHAT TO SEE WHEN LIFE DRAWING

There are two principal factors that contribute to convincing life drawing. The first is selection of visual elements applied through abstract analysis when viewing the model. The second is seeing and interpreting the physical pose of the model. The pose can communicate emotional characteristics: relaxed, tense, aggressive, in motion or buoyant. The character of the pose plays an intrinsic role in the expressive quality of the drawing.

The human form conveys individuality. We identify with and recognize individuality through physical characteristics like big, small, fat, slim, young, old, male and female. The figure can stand, sit, lie, twist, squat and lean. The human form has five appendages that extend from the torso: two arms, two legs, and a head; all can move or point in different directions. The body is flexible and capable of communication through the pose.

There are visual challenges in seeing and drawing the figure as a single unit in a specific position.

Analytical, abstract analysis is necessary for reasonable success. The conventional tendency is to concentrate on individual parts of the body and all too often the drawing ends up with the head, legs or arms extending off the drawing paper or the body not being large enough to occupy the paper in balanced proportion and composition.

A life drawing is an interpretation and visual expression, even if the intention for the drawing is to achieve true likeness and high representation. Through selection, the drawing should communicate the essential characteristics and character of the pose.

Consistent practice and deep concentration are necessary when life drawing. The rewards can be particularly beneficial to improving visual literacy.

ANALYTICAL ABSTRACT ANALYSIS AND THE LIFE FIGURE

Physical stature

Practice skill: the set-up.

Before beginning life drawing, take a moment to walk around the pose. Observe how the figure's physical components change from various viewpoints and in relation to each other. The physical characteristics of the model are evaluated at this time. Figure 99 suggests a large, heavy-set female, seated and leaning with her weight on her right elbow. The pose is relaxed and gives the impression that the model could sit in this position for a long time.

The red line in Figure 100 indicates the angle of the torso and the specific point of change in angles between the torso and legs. The shape of the torso, head, and arms are set up within one geometric shape above the red line and the legs and feet are set up within the geometric shape below the line. These shapes (the abstract analysis) help to set up the accurate position and character of the pose and the correct proportions of the figure on the drawing paper.

Drawing the character of the pose keeps the focus in the centre of the drawing (Figure 99). Even though there is a sense of visual support (expressed by hatching and cross hatching values, details and accents) on the left-hand side of the drawing (accented on the elbow, chair, and knee), the viewer is visually steered back to the centre by the rendering of the hand on the left thigh. This 'visual triangle' (illustrated by the blue triangle in Figure 99) of elbow, knee, and the hand positioned on the left thigh, is established through rendering these three parts of the body and selecting (a conscious

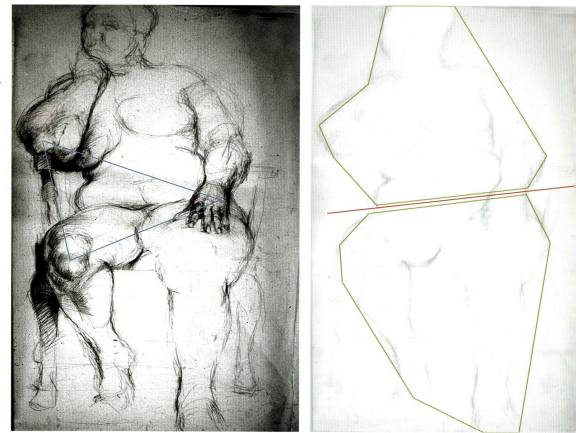

Figure 99 (*right*) Manwaring (first name unknown), 1962. Pencil on paper, showing rendering on elbow, hand and knee, 84 x 60 cm.

Figure 100 (*far right*) Setting up the drawing, applying abstract analysis.

visual decision) to leave other parts of the body *without* bold accent or rendering. Selective rendering gives visual weight to the pose, describes form and focal point and adds rhythm, movement and variety.

The element of line is used to communicate the physical character of this pose. Many lines are visually subservient to the more heavily rendered areas which create a visual movement of the eye through the pose. This is the intention in the composition which gives the drawing its individuality and vitality.

Careful selection of what is and what is not rendered are critical decisions based on clear intention and how the feeling of the pose is communicated.

DRAWING THE CHARACTER OF THE POSE

Figures 101 and 102 illustrate the partially drawn figure where carefully selected rendering has been applied to communicate the character of these poses. In Figures 101 and 102 the feeling of tension is interpreted and expressed.

In Figure 101 the ribcage, head, and arms are hanging over the edge of an implied platform. There is no drawn evidence of this support. The head and arms feel as if they are being pulled down and this creates 'push-up' through the rib cage, expressing tension. Tension is exaggerated in the carefully selected balance between rendered areas and areas that are not rendered.

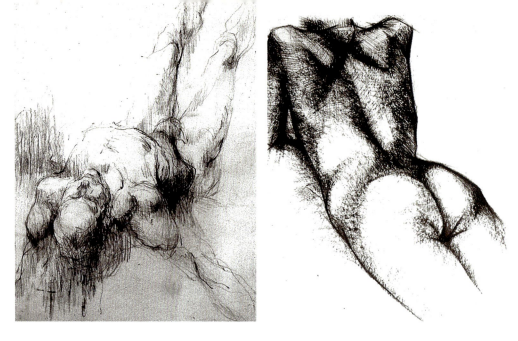

Figure 101 (*far left*) Hicks (first name unknown), 1963. Pencil on paper, 84 x 60 cm.

Figure 102 (*left*) David Cohen, *circa* 1980. Charcoal on paper. 84 x 60 cm.

This intention also applies to Figure 102. The tension in the buttocks runs up the spine to the scapulas, which are pushed together by the weight on the arms.

The intention in Figure 103 depicts a relaxed pose and feeling in the drawing.

The hatched and cross-hatched lines express curvaceous forms. The contrast between rendered and non-rendered areas serves to emphasize the relaxed nature of the pose, complemented by the soft surface the model is lying on. The diagonal visual flow from left to right gives the drawing a calm and serene feeling.

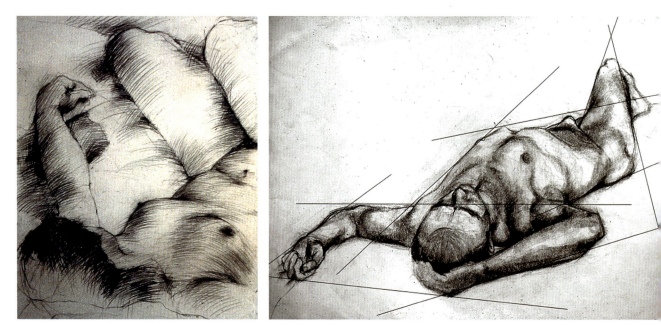

Figure 103 Kirstie Cohen, *circa* 1984. Pencil on paper, 84 x 60 cm.

Figure 104 David Cohen, 1962. Pencil on paper, 84 x 60 cm. Illustrating geometric (abstract) analysis using sight lines to divide the component parts of the figure to achieve correct scale and proportion.

The reclining figure in Figure 104 demonstrates foreshortening: the scale of the anatomical parts diminishes dramatically in size from head to feet. Foreshortening can cause considerable challenges in establishing a pose within the parameters of the drawing paper. Abstract analysis helps to set up 'line structure', which can help to establish correct proportion before rendering is applied. If the intention is to represent what is being observed accurately, the visual relationship of all the anatomical parts in the composition is vital.

DRAWING THE DYNAMIC POSE: EXPRESSIVE APPROACHES

In Figures 105 and 106, formal representation is not the intention. The expression of visual movement and motion is the goal. The arms in Figure 105 appear to move together with the rotation of the body. This movement is expressed by avoiding specific detail. Success depends on the energy expressed in drawn line and the maker's emotional response to the motion of the figure. It is impossible to view this drawing without feeling movement. Figure 106 expresses motion in a different way: the axis of motion focuses on the pelvic region, two torsos hinged on a single pair of legs. The feeling of movement up and down is expressed.

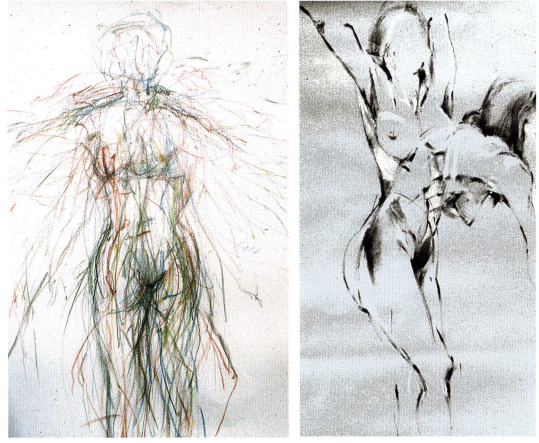

Figure 105 Unknown artist and date. Coloured pencil.

Figure 106 Unknown artist and date. Charcoal and crayon.

Figure 107 Unknown artist and date. Collage.

Figure 108 Unknown artist and date. String, pins on board.

Collage

Figure 107 is an abstract expression that plays with anatomical parts, clothing, objects and colour to create a bold visual statement that has strong figurative qualities.

String and pins on board

Drawing with string (Figure 108) requires a large board and a lot of pins or a staple gun to attach the string. The direct method is quick and easily changed. Drawing with string on a large scale challenges and assists understanding of form, shape, line and space through abstract analysis. This helps to see visual elements clearly, without the need for detail.

ACADEMIC TWO-DIMENSIONAL DRAWING AND THREE-DIMENSIONAL MODELLING

Figures 109 and 110 illustrate the academic study of the life figure from two-dimensional drawing to three-dimensional modelling. Two-dimensional life-sized drawings of the model (visible in the background in Figure 109) were made from four positions; front, back, and two side views, then modelled in clay (Figure 109) and then plaster (Figure 110) for greater detail and refinement. These were academic exercises for acquiring necessary skills and technique and at the same time learning to see scale, form and proportion in three dimensions.

Figure 111 shows life-drawing studies taken from photographic poses. Expressive sketches were drawn (A and B) to reveal feelings and intentions for the three-dimensional work (C). Drawing plays a critical and necessary role in exploring form and intention.

Figure 109
(*opposite, top left*) David Cohen, *circa* 1961. Edinburgh College of Art.

Figure 110
(*opposite, top right*) David Cohen, *circa* 1961. Edinburgh College of Art.

Figure 111 A, B, C
(*right*) Unknown artist and date. Drawing studies from photographs resulting in finished sculptures.

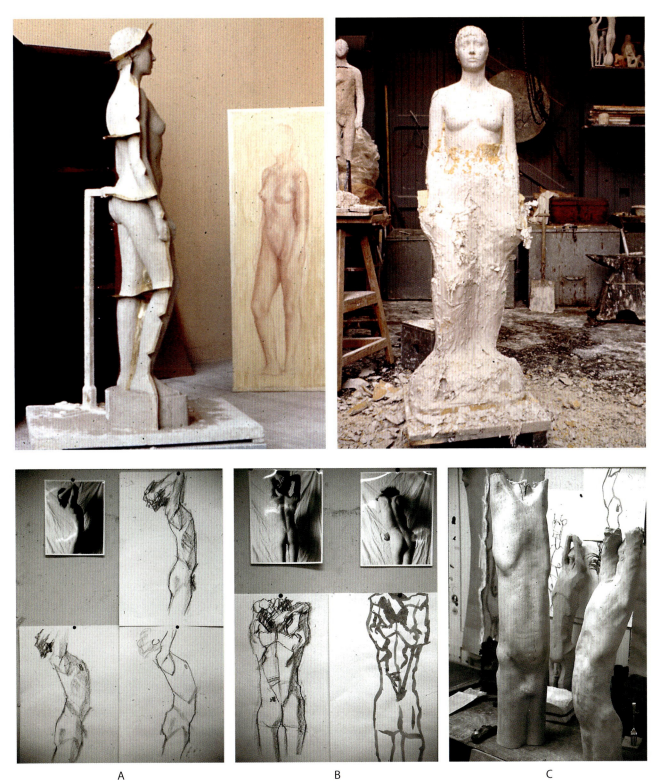

A

B

C

SELF-EXPRESSION INSPIRED BY THE HUMAN FORM

To conclude this chapter, examples of self-expression referencing the human figure are illustrated. Appreciate that all the artists studied the figure as part of their art education. They practised drawing and/or modelling the figure in an academic manner to improve visual literacy and techniques, before they considered using the figure to communicate their intentions.

From an academic foundation they were able to develop a highly personal style, using materials and approaches that make their work original.

David Cohen

Advanced drawing skills are essential to the intention and representational nature of Figure 112, as well as a deep understanding of the human form. The ceramic tiles are the 'paper' on which the drawing was executed using coloured ceramic pencils.

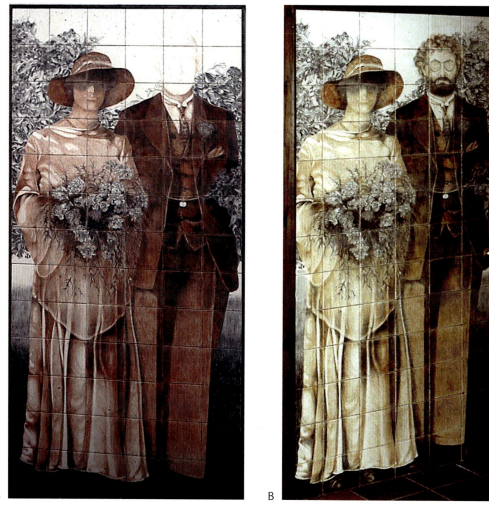

A B

Figure 112 A drawing in progress; **B** finished work. David Cohen, 1987.
Ceramic pencil on ceramic tiles, mounted on plywood and wooden doorframe.

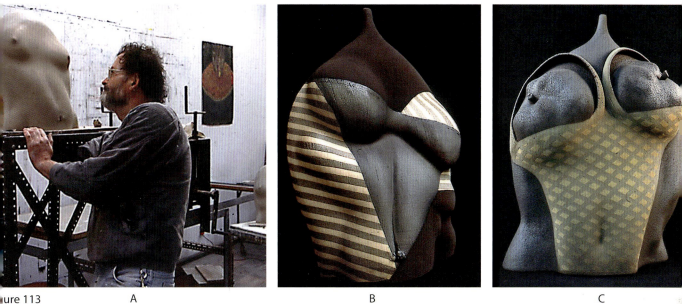

A B C

The torso forms in Figures 113 and 114 were 'pushed out' by hand (Figure 113 A) from the inside when the clay was leather hard. This takes great care and patience and an acute sense and understanding of form. Cohen's drawing skills and his understanding of the human form contributed to his ability to model the figure in a three-dimensional context. The greater one's vocabulary and technical skills, the more adept one becomes at applying them across different mediums and dimensional forms.

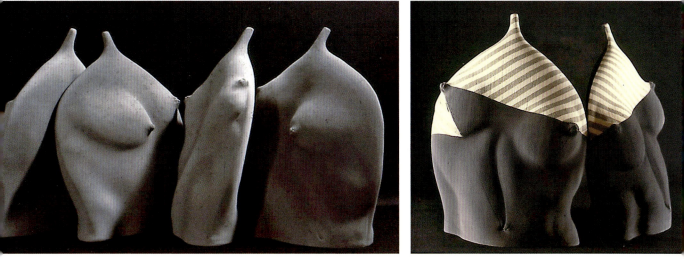

Figure 114 David Cohen, 1996. Press-moulded and hand-sculpted ceramic. Approximate height 64 cm.

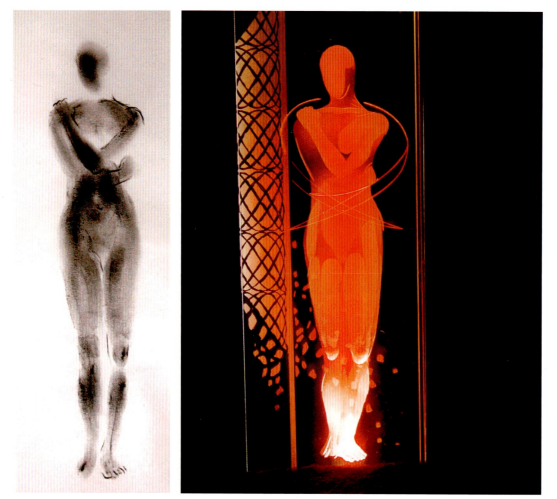

Figure 115 Alison Kinnaird, *'Psalmsong'*, sketch.

Figure 116 Alison Kinnaird, *'Psalmsong'*, finished glass engraving.

Alison Kinnaird

The poses in Figures 115 and 116 are interpreted in a number of ways. A single line can change the emotional character of the figure. Different details are picked out in the relief of the engraving, but the maker is always aware of the underlying anatomical structure. The soft blocking-in with white chalk is highlighted with a few lines to define the detail. The engraving may select different ways of presenting the structure because working with sculpted mass, rather than a line, shows the figure in three dimensions.

The engraving in Figure 117 focuses the viewer's attention on the hands, which are depicted in detail. The choice is often 'how much to leave out', rather than how much to include. As confidence in drawing skills increases, it is possible not to be so explicit, to suggest forms, rather than show them literally.

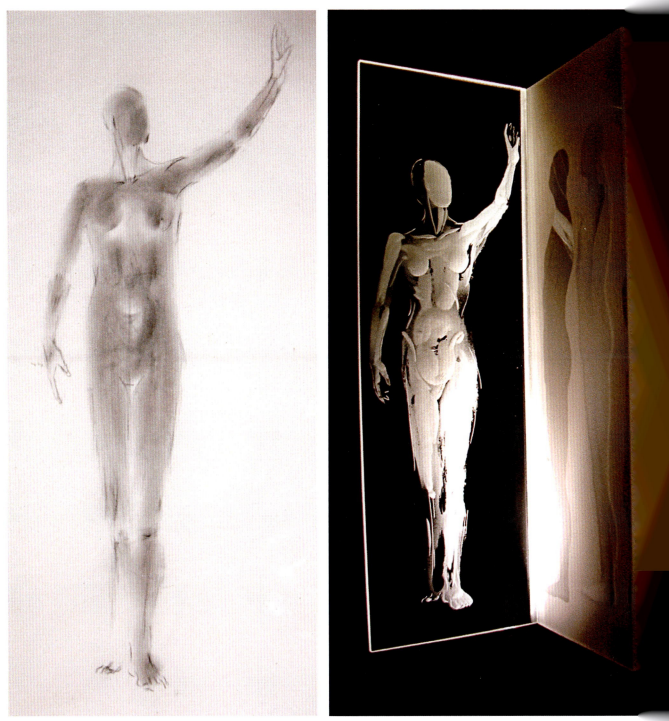

Figure 117 Alison Kinnaird, '*Point of Entry*'. Sketch and finished engraving.

Craig Mitchell

Mitchell's work has many visual and conceptual qualities that captivate the viewer. He uses the figure as a way to make characters that often invite humorous narratives.

I try to express ideas using humour to 'sugar the pill', sometimes creating unlikely scenarios or ridiculous juxtapositions drawing the reader into these tales with a smile before being faced with a mildly chiding finger.

craigmitchellceramics.com

His selection of visual elements is particularly acute and precise. Every detail matters to the impact of the character's story. The viewer is inspired to try to make sense of the absurd and in doing so makes an intellectual leap to a place of dreamlike possibilities and challenging realities.

Realising slightly surreal ceramic creations is my way of relating to the increasingly bizarre reality which forms the fabric of our daily lives.

craigmitchellceramics.com

My work explores contemporary culture and universal themes but also responds to current events, both political and personal. Everything in my life, every chance comment, every potentially insignificant interaction and childhood memory is mixed into the melting pot of my work.

craigmitchellceramics.com

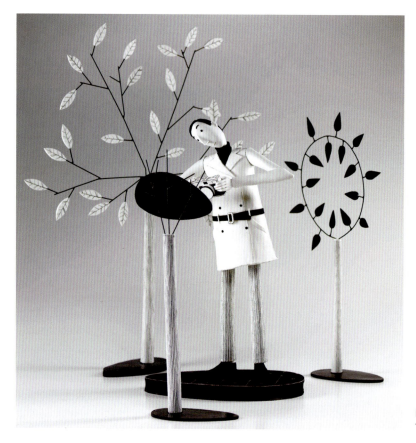

Figure 118 Craig Mitchell, *'Heirlooms'.* Porcelain.

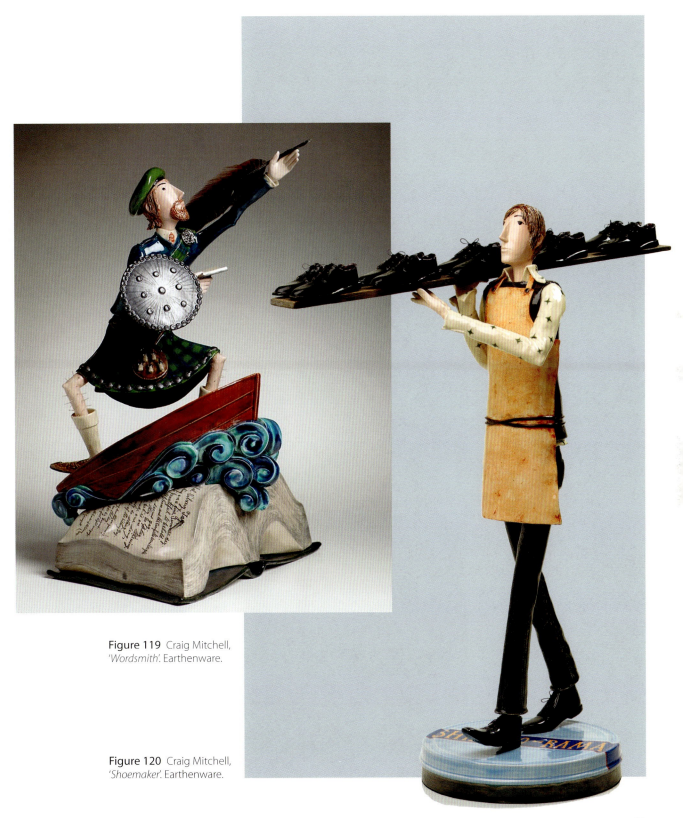

Figure 119 Craig Mitchell, 'Wordsmith'. Earthenware.

Figure 120 Craig Mitchell, 'Shoemaker'. Earthenware.

Scott Anderson

This series of work illustrates Anderson's approach to the figure in reference to his passion for long-distance running. Using photographs of his body was important with respect to his expression. He also references Eadweard J. Muybridge's images of human locomotion.

Different aspects of the runner and running, Figures 126 and 127; physical exertion, Figure 127; movement, Figures 121 and 122; apparel and anatomy, Figures 123–125, are all made using photocopies and drawings that were sliced and layered.

The technique of slicing and layering the paper (so that the image underneath shows through the image on top) creates texture and depth and a sense of movement on the surface. The scale of the work was important: the human form was larger than life to add visual impact for the viewer.

Figure 121 Scott Anderson, 1993. Sliced paper and photocopy, 243 x 42 cm.

Figure 122 Scott Anderson, 1993. Detail: sliced paper, charcoal, photocopy, 30 x 42 cm.

Figure 123

Figure 123–127 Scott Anderson, 1993. Sliced photocopy paper,120 x 168 cm.

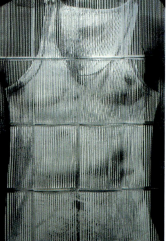

Figure 124

Figure 125

Figure 126

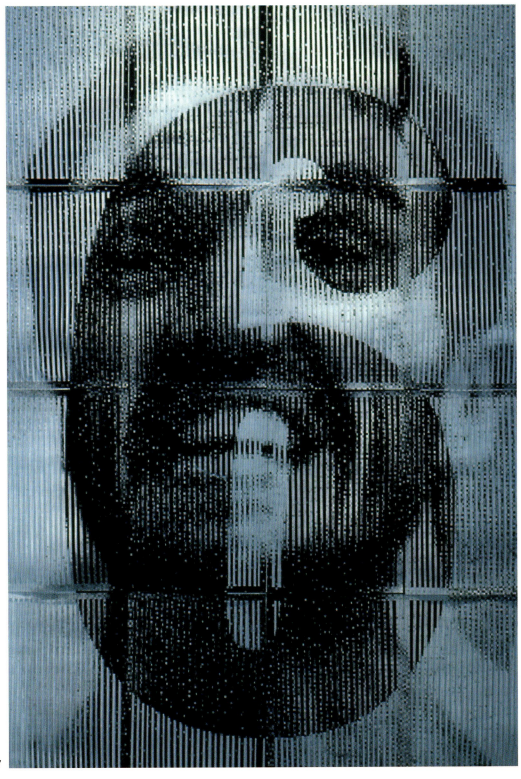

Figure 127

SELF-PORTRAIT

Like life drawing, self-portraiture has been a recurring theme of interest and study for artists. One could equate the self-portrait to the writer's autobiography; a visual approach to telling a personal story, a way for the visual artist to capture some essence of their being, character, moods, attitudes, beliefs, fears, loves and hates at any time in their life. The portrait is a way to visually reveal aspects of the self without words.

The approach to self-portrait should always be personal. This is the outcome: to reach a conclusion that is unique and a true expression of character.

There is a danger of getting too self-conscious and letting this overwhelm and intimidate attempts to get close to an expressive approach. Don't get too concerned with the need to draw the perfect nose or the perfect lips. Try to loosen up and just draw. Don't get too focused on specifics. Get the set-up established (scale, proportion, form), then concentrate on rendering detail.

The examples by Scott Anderson (Figure 128 A–E) show many anatomical inaccuracies and yet these are strong, committed, bold drawings that do communicate a strong sense of character. This should always be the goal in any self-portrait. Reference to the portrait in art history is useful to appreciate different approaches and styles.

Practice skill: Always draw from life using a mirror; never draw a self-portrait from a photograph. Drawing from a photograph is very poor practice because the photograph is already composed and all the decisions regarding light, form, shape, line, texture and colour have been already captured in a static illusion. The drawing will be a copy, unauthentic, lacking life and weak. Drawing the portrait using a mirror gives a drawing uniqueness, authenticity and energy that are only captured when drawing from life.

Draw on a large piece of paper (A2 or 18 x 24 in) so that you can draw the portrait life-size or larger. Use any medium you like. The series of five charcoal portraits (Figure 128) were completed within a week; they are arranged chronologically. The portraits became increasingly representational and formal, however the character is perhaps a little stronger in the earlier drawings.

Self-portrait should be liberating, cathartic and reflective. Expressing qualities like character, emotion, narrative or symbolism is a more important intention than photo-realism.

Andy Warhol and his portrait series of collage silkscreen prints inspired Anderson's collage self-portraits at the bottom of the series (Figure 128, F and G). This is a different approach from drawing in front of a mirror. Placement and organization of colour, drawn line, cut-out paper shapes, and photographic image are carefully selected, placed and organized to create a balanced composition.

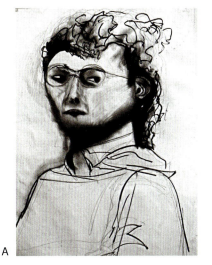

A

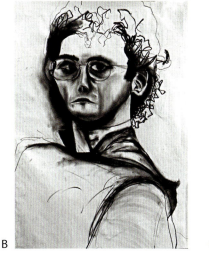

B

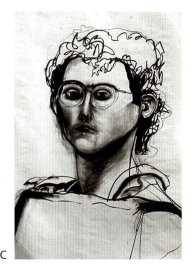

C

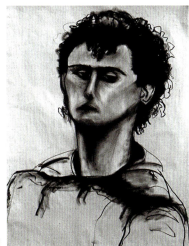

D

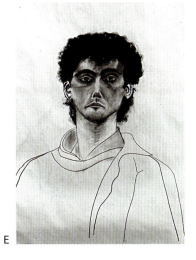

E

Figure 128 A–G
Scott Anderson, 1991.
A–E, charcoal on
newsprint.
F and **G**, coloured
paper, photograph
and ink collage.

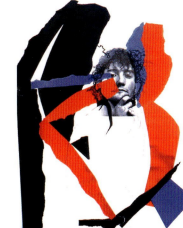

F

G

5 SELF-EXPRESSION AND VISUAL PRACTICE

VISUAL PRACTICE

With over sixty years of combined teaching and making experience, we never tire of exploring ways to reflect on visual practice. We have discovered that there are common qualities that support this reflection and are inherent to the process of creating something of value.

This chapter highlights qualities of visual practice and explains them using Figure 129. Visual practice embraces design thinking and visual problem-solving to help illuminate pathways to self-expression.

Visual practice explained

This chapter explains visual practice, breaking the diagram down into four parts:

- the idea
- principal components: the importance of the sketchbook
- visual development
- finished work.

Chapters 1–4 introduced visual language through practical approaches to two- and three-dimensional making. These approaches, together with essential skills and techniques, were designed to help increase visual literacy through critical assessment and practice. The chapters come together here.

A solid theoretical framework plays a small part in achieving success in visual disciplines that are practical, experiential, hands on and require hours of meaningful practice. Theory can be a useful reference and guide to practice, and there is merit and perhaps some comfort in knowing that there are important parts to the creative process that can contribute to success.

We conclude this text by presenting selected artists from a variety of visual disciplines, who show examples of their work and present their reflections on approaches to self-expression. Each artist provides candid responses and insights to their understanding of visual language and its application in their work.

What is revealed is that there is no singular or 'best' approach to visual practice. At the core is visual language. What is most important is discovering what works, and we hope that this text and the artists' contributions help in this regard.

Creative problem-solving is never predictable or linear, and success is never guaranteed. It is however, self-directed and must begin with ideas. From this starting point, work can take form.

In many serious creative pursuits, the focus is not on final outcome but on what is discovered and revealed along the way. Conclusions become starting points for the next idea, and that is always the best part of any journey. With accumulated vocabulary and experience, this never-ending journey takes infinite and often unexpected directions.

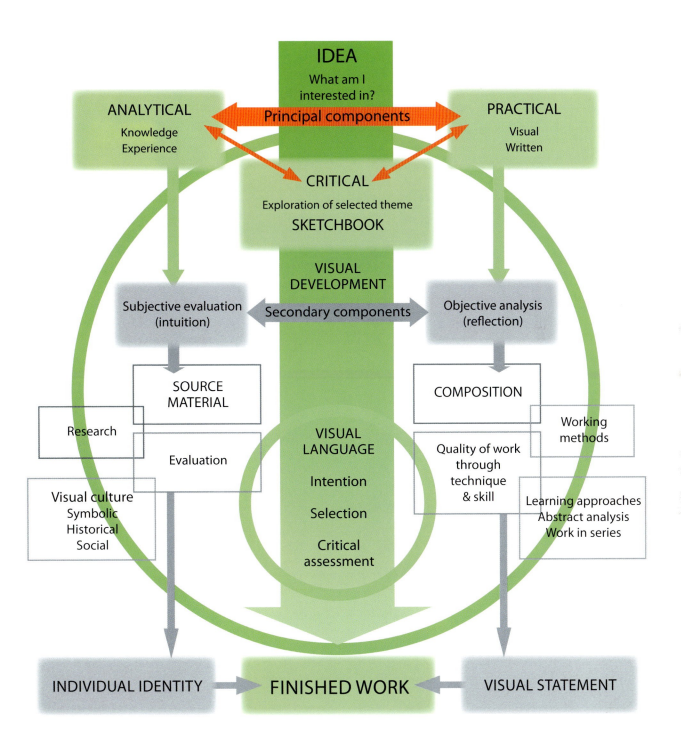

IDEA
What am I interested in?

ANALYTICAL
Knowledge
Experience

Principal components

PRACTICAL
Visual
Written

CRITICAL

Exploration of selected theme

SKETCHBOOK

VISUAL
DEVELOPMENT

Subjective evaluation
(intuition)

Secondary components

Objective analysis
(reflection)

SOURCE
MATERIAL

Research

Evaluation

Visual culture
Symbolic
Historical
Social

VISUAL
LANGUAGE

Intention

Selection

Critical
assessment

COMPOSITION

Working
methods

Quality of work
through
technique
& skill

Learning approaches
Abstract analysis
Work in series

INDIVIDUAL IDENTITY

FINISHED WORK

VISUAL STATEMENT

Figure 129

THE IDEA

When beginning work, it is useful to ask: 'What am I interested in?' This simple question can be difficult to answer, but it lies at the heart of any motivation, desire, and enthusiasm for creating work of value.

IDEA
What am I interested in?

Figure 130

PRINCIPAL COMPONENTS: THE IMPORTANCE OF THE SKETCHBOOK

The importance of the artist's sketchbook (Figure 131) should never be underestimated. It is a vital part of the maker's creative process. The sketchbook is deeply personal, private and rarely seen or shared. The relationship between sketchbook contents and the final artwork(s) often reveals approaches to seeing, feeling, writing, research, collecting and critical thinking that all in some undefined way can contribute to the content and form of finished work.

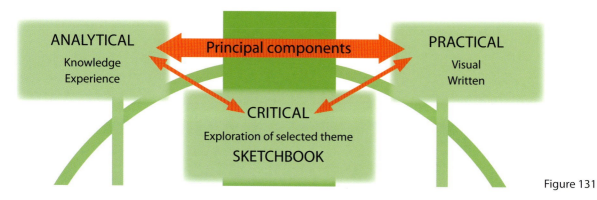

Figure 131

The sketchbook is where visual language is exercised, researched, developed and refined so that selection and intention can come into focus. Without the sketchbook, a starting point for ideas is often more difficult.

There is no single or clear purpose for the sketchbook, but it often serves as a preferred location for research findings, discovery, intuitive exploration, fact-finding, preliminary drawing, planning, journal entries, writing, note-taking, playing and free association of ideas. The sketchbook is the place where the maker can feel most free, where anything goes and the unexpected and intuition are most valued.

SKETCHBOOK CASE STUDY: KIRSTIE COHEN

The following examples illustrate extracts from Cohen's sketchbook and conclude with examples of her landscape painting. This provides a flavour of her complex and personal uses for her sketchbook, the development of her ideas and finished work. These examples and comparisons are not definitive. What should be appreciated are visual, critical and intuitive connections.

Cohen's examples reveal a sense of the importance and value of the sketchbook as a tool and a space for analytical, critical and practical contributions. Every artist will utilize their sketchbook or journal in the way that they find most helpful in their work. There are no specific methods, skills or techniques to this.

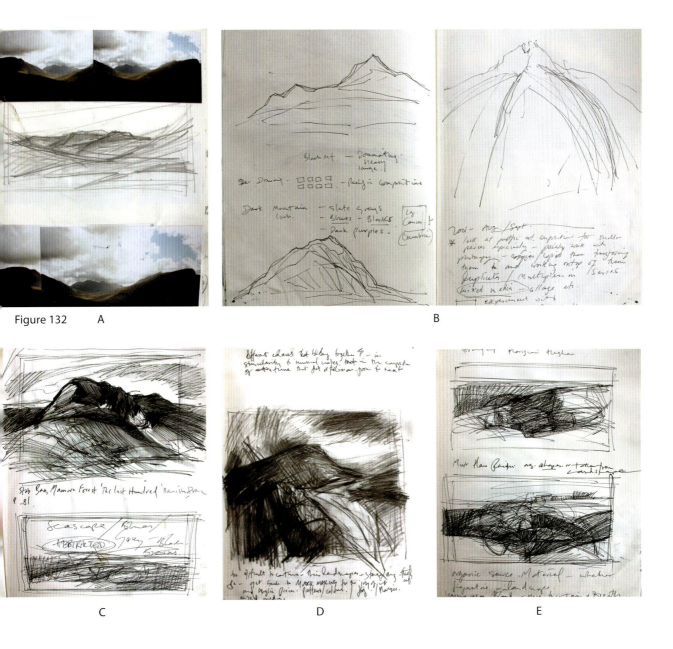

Figure 132 A

B

C

D

E

In these examples (Figure 132 A–E) Cohen begins by taking photographs (A) of an actual mountain landscape that she witnessed. These are placed in the sketchbook. In between the photographs are sketches for visual reference, a reminder of moods, colours, textures, lines and shapes. These elements and emotional qualities may eventually contribute to a painting.

Preparatory drawings and sketches (Figure 132 B–E) document and evaluate compositional possibilities, shapes and mood. Scale and depth are also explored. Writing plays a role in recording and reflecting on thoughts, details and feelings. The sketchbook can easily be carried on journeys into landscapes.

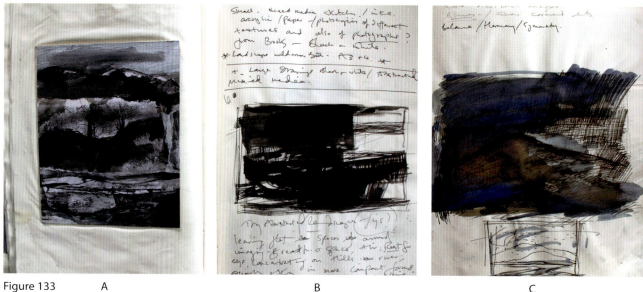

Figure 133 A B C

Cohen's finished paintings (Figures 134, 136 and 137) are never of a specific location. They express memory, feeling, mood, all captured as part of her emotional responses and experiences. The sketchbook helps to contribute to the quality of the finished painting. It builds vocabulary.

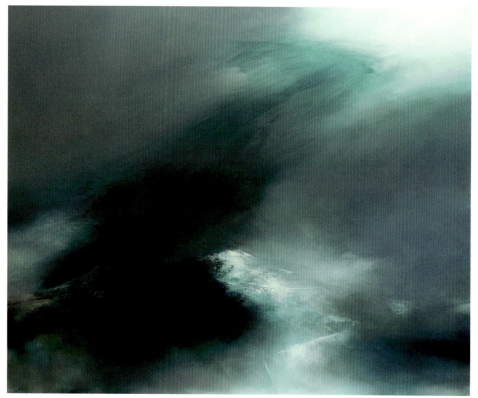

Figure 134

Figures 133 A–C are field sketches. They fuel an intuitive, emotional response to an actual or imagined experience. It is never predictable how the sketchbook will contribute, but it all adds to Cohen's vocabulary. The sketchbook is a visual, emotional and intellectual memory and record to be tapped into when needed.

Cohen experiments with different palettes of colour by making preparatory 'sketch paintings' (Figure 135 A and B) on a small scale, to determine mood and feeling. These examples illustrate this by comparing the cooler palette and darker mood in Figures 135 A and B with the warmer palette in Figures 135 C–E. The sketches help to move Cohen towards clearer intentions, refine her selection, and determine a starting point for the actual painting (Figures 134 and 136 use a cooler palette, and Figure 137 a warmer palette).

Sketch paintings are Cohen's informal, free, and quick visual responses. They serve as a jumping-off point towards a more definite commitment and direction, like a road map towards a destination that is both known and unknown. Cohen's intuition, experience and skill all work together to realize an outcome for the finished work. Without the sketchbook, much of the quality in her finished painting might not come through.

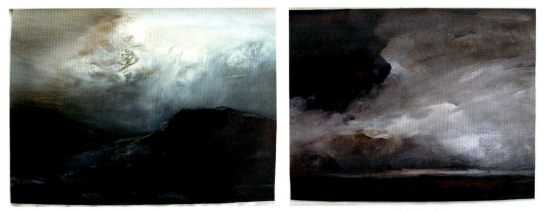

Figure 135 A B

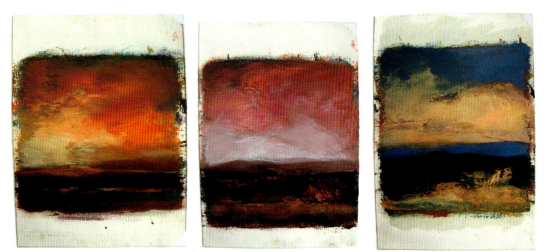

C D E

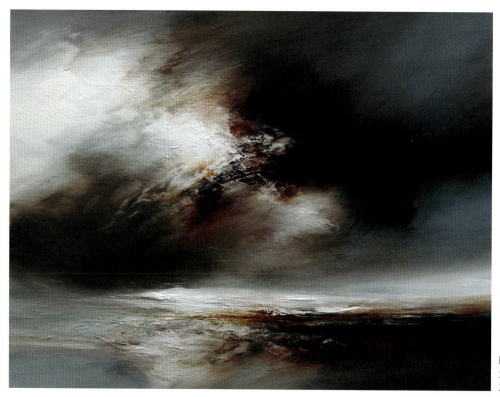

Figure 136 Kirstie Cohen. *Snow Cloud*. Oil on gesso, 23 x 44 cm.

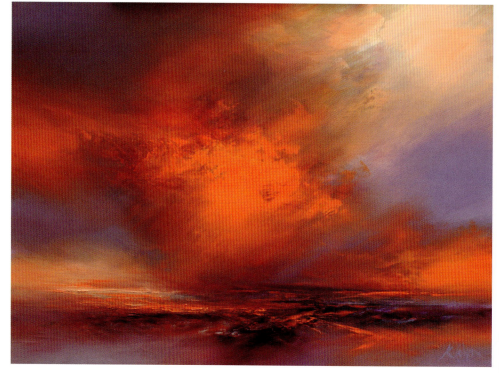

Figure 137 Kirstie Cohen. *Orange Cloud Rising*. Oil on gesso, 29 x 39 cm.

VISUAL DEVELOPMENT CASE STUDY: DAVID COHEN

The following series of work began with photographs (Figure 138). The idea can be simple. No subject, object, theme or idea is any better, worse, easier or more difficult than any other. What is of interest is a personal choice: the quality of what is made is most important.

Themes in nature have interested Cohen for thirty years, so it would be misleading to suggest that the banana theme was entirely unrelated to previous work. This series of work continued and extended his interests and explorations of fruit and nature.

Figure 138

The photographs in Figure 138 reveal Cohen's analytical approach to the banana plant, applying his prior knowledge and experience from previous studies to the task of selecting visual information that he felt was useful. The unique character of the banana plant exhibits a rich variety of line, shape, texture, colour and form. Cohen selected visual elements, providing the practical and visual foundation upon which he could begin work.

Cohen's drawings were the principal method through which his analytical, practical and critical vocabulary were developed. The drawings began in a representational manner (Figure 140 A) and developed towards increasingly abstract compositions (B and C). This process of discovery, evaluation and exploration may take weeks before an intention takes form.

Drawing (in combination with methods of researching source material: reading, writing, collecting and referencing historical, symbolic and social sources), as a primary method for visual development,

Figure 139

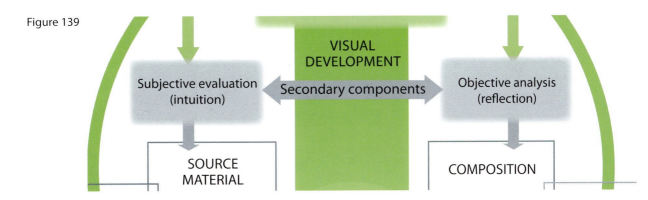

Figure 140 A

B

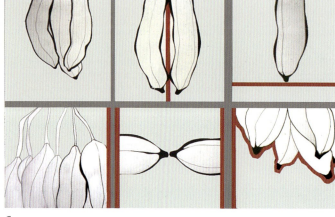

C

helped to focus his intention and intuitively evaluate his subjective relationships to source material. Drawing also clarifies objective analysis in relation to composition, selection of materials and skills needed to make work.

A series of multiple drawings or three-dimensional works is always more helpful than one or two. A series establishes reference points to compare and contrast one drawing with another. A visual and critical dialogue between the drawings and the maker is established. This is a particularly practical and useful way of seeing and realizing intentions and directions for development of the theme. As more work is made, deeper connections are possible in objective analysis and subjective evaluation.

Subjective evaluation is an inner dialogue that is driven by and explored through perceptions and feelings related to the theme. It is an intuitive expression in the process of making, where feelings and notions are captured and expressed visually.

Objective analysis is applied through the conscious selection, placement and organization of visual elements (line, shape, tone, texture, colour, form, light) using the medium of choice (glass, steel, ceramic, paint, etc.) so that the work can be realized.

Cohen's goal from the beginning was to develop ways in which he could explore the banana and fruit theme in ceramic forms.

Finished work

Cohen's series of ceramic platter forms (Figure 141 A–D) are an extension of the banana drawing series (Figure 140 A–C). Like a piece of paper or a painter's canvas, the ceramic platter forms enabled Cohen to continue 'drawing' with coloured clay. He developed his technique by mixing different-coloured clay. After carefully placing and organizing the coloured pieces on the blank form, he then used a flatbed roller to compress the coloured clay into the blank slab. His visual language (abstract analysis, composition, intention and selection of visual elements), comes together in this series.

The platter series illustrates the development of the composition and the strong visual dialogue that exists between them. They all visually relate to one another and yet they are all different. The composition becomes increasingly abstract and the representation of the banana becomes less evident and increasingly expressive.

The next phase considered ways to make the banana and fruit themes in three dimensions.

Figure 141

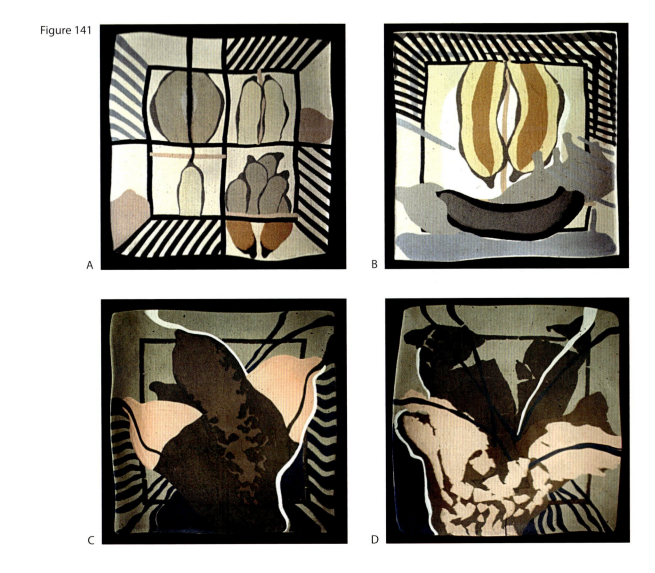

A

B

C

D

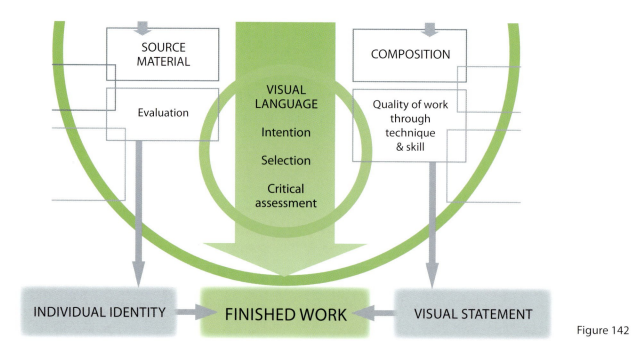

Figure 142

Figure 143 shows Cohen's commitment to and passion for the idea in his studio. Without total involvement and immersion in making, little of any lasting value results. His identity and style in the finished work emerge through his practical and aesthetic development of the idea and theme. His work in progress illustrates a sense of subjective evaluation and objective analysis in synthesis and action.

In a three-dimensional context it is essential that the form be made so that it can be critically evaluated. Drawing in this regard can only take you so far because of the two-dimensional limitations to seeing the form completely in relationship to actual space. These examples (Figure 144) can

Figure 143

also be seen as a series, in the same way as the drawings (Figure 140) and the platters (Figure 141). The three variations in composition communicate intention and visual evidence of Cohen's inner dialogue and critical evaluation.

The banana theme was extended to include watermelon. Figure 145 A and B illustrate variations in composition and freedom expressed in the development of the drawing.

The watermelon begins to dominate the banana form in Figure 145 B and eventually becomes the sole subject in Figure 145 C. A large-scale drawing and sculpture (C) with reference to the watermelon are exhibited together to create a visual dialogue between the two pieces in the gallery space.

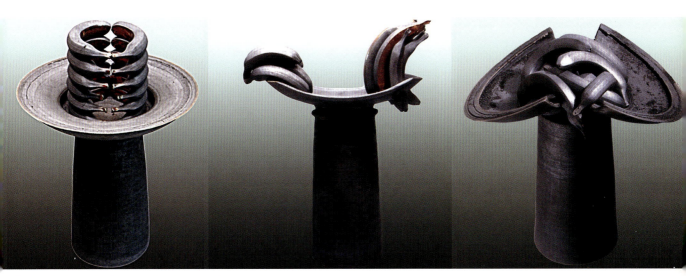

Figure 144 Finished work resulting from studio work (Figure 143).

Figure 145 A B C

CREATIVE PRACTICES: ARTISTS' PERSPECTIVES

Colin McPherson – photographer

I was born in Edinburgh, Scotland, and began working professionally as a photographer in the late 1980s. I make work using both digital and traditional formats. I am inspired and motivated by social and environmental consequences of human interventions and actions around the world as well as reportage of important political themes.

Visual language is the cornerstone of my creative process. It provides the basic framework into which detail can be incorporated and allows work to be developed and completed. It is a metaphysical narrative, based on specific elements of the creative process that I use intuitively to create work.

Working in the medium of photography requires three separate and distinct phases to be realized: the selection of the subject, the moment (however long) of making the photograph and the arena of post-production when decisions on the representation of the final work are made and concluded. Into all three of these realms I aim to apply a universal test, namely that the work can be analyzed through its composition, colour and content and found to be complete. The use of these 'Three Cs' as a basic requirement informs

Figure 146
Colin McPherson.

everything from the choice of the subject, through the way the photograph is constructed visually to the outcome or its physical representation and manifestation. Knowledge of the subject, the materials (mechanical or otherwise) and the process only serve to strengthen the final outcome to the point where I can 'let go' of the work and allow it into the public realm. The most interesting and least tangible of these three phases occurs in the actual moment when the photograph is made.

This is the point of coalescence, when the deep knowledge of the processes involved is triggered by an innate sense of the moment.

Another practical element, which determines how and when I make images, is the process of pre-selection. This process involves looking at a subject, or evaluating a moment into which I will intervene and make the image. For this to be realized successfully, I rely not on looking through the lens of the camera to 'hunt' for something, but rather evaluate what I am seeing without the camera. This allows the context of the composition to be trialled in my mind before I execute the image. Naturally, sometimes this process is swift, maybe only a second or so, so as to allow me to capture the precise moment into which all the elements fit within the 'Three Cs' concept. In the examples of my work, we can see both approaches.

In 'Salmon netsman, Armadale', 2003 (Figure 147) and 'Jaffa', 2010 (Figure 148) the time between evaluating the scene and making the image is minimal.

To delay would be to allow the possibility that those elements of composition or content could be altered in an undesirable way. In my other two examples, however, time plays a lesser role, allowing the critical compositions to be made without this consequence.

In 'Fiddler's Ferry' (Figure 149), the main element is the intersecting of a diagonal with the horizontal. This element would have been constructed carefully by looking through the lens after having selected the scene to be photographed. I have a strong sense of elements of composition moving into place, which I then apply by looking through the lens.

The final example I have chosen, 'Slaithwaite' (Figure 150) combines the two examples.

Figure 147
Colin McPherson, 2003.
'Salmon netsman, Armadale'.

Figure 148
Colin McPherson, 2010. *'Jaffa'.*

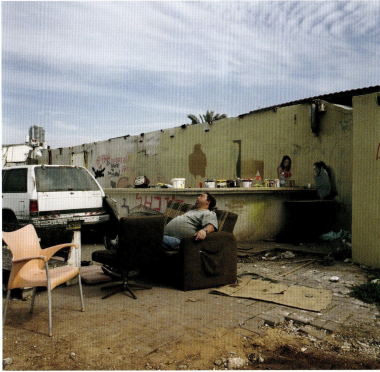

Figure 149
Colin McPherson, 2007.
'Fiddler's Ferry'.

Figure 150
Colin McPherson, 1998.
'Slaithwaite'.

First, the scene is identified by eye, then the rules are applied once I am framing through the lens. The key aspect of the composition of the image is the 'V' shape of the wall at the bottom, which lifts the scene up and focuses on the subject; the rain-soaked horses, thereby framing the whole image. The coalescence of subject and composition is therefore achieved.

I am often (but not exclusively) required to interact with the subject of my work and therefore interpersonal skills and knowledge of the subject are of overriding importance in this dimension. A sense of place, timing and awareness of context are other qualities which I deem necessary to successful outcomes.

The striving to find one's own distinctive style or creative 'voice' is a process that is at the core of my work. The ability to comprehend and reinterpret influences and to allow myself as the creator to have space and scope to develop a coherent narrative through the visual medium is a constantly evolving process.

It is imperative that the creator keeps a sense of trajectory through his/her career as an artist. The constant re-evaluation of one's own and others' work, both in terms of content and practice, is the only authentic way to realizing a true creative path or journey.

Visual language can be learned, but the artist must strive to connect with his/her inner voice, which will be the guiding force on an artist's journey.

Figure 151
Scott Anderson.

Scott Anderson – installation

I was born in Edinburgh, Scotland; I completed my MFA in Drawing and Painting at Edinburgh College of Art in 1999. In 2004 I moved to Massachusetts to teach art and design at Cape Cod Community College. I've been exploring my interest in movement (I have always loved long-distance running) through art installations since 1993. I've never pigeon-holed myself with respect to the 'kind of art' I make, being more comfortable with the sense that I simply enjoy making. The medium I choose to work in is always carefully selected and appropriate for my intention and the location of the work.

Visual language underpins my teaching philosophy and my approach to making art. I've grown to understand selection and my application of visual elements and also the determination and risk involved in finding intention in my work. I think it's important to be able to see process. I've selected 'Run #5' (Tao Water Gallery, 2011) to illustrate my exploration of movement and spatial relationships. I began by responding to visual elements in the gallery space: scale, shape, line and light. These fed my imagination and energy for a playful and physical challenge in altering the space.

The gallery space offered three flat walls and two corners to consider. Because the central wall is larger than the two side walls, it dominates the viewer's visual and physical experience. I selected geometric painted shapes to create the illusion of dimension on a flat surface in dialogue with the three-dimensional space created by the addition of string.

My intention was to challenge perceptions of space as the viewer moves around and through the work. The process of making the work and the viewer's relationship to the work requires movement. I see the whole piece as a 'movement drawing'. The string and

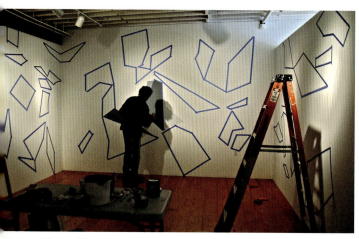

Figure 152 Scott Anderson. '*Run #5*'. Beginning work.

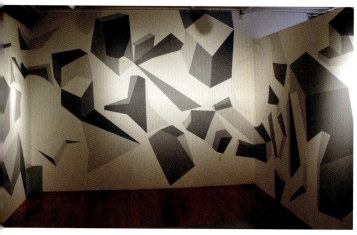

Figure 153 A Scott Anderson. '*Run #5*'. Painted walls, before string.

painted shapes create a rich variety of line and shape relationships, resulting in a balanced composition and use of space. I feel it's complete when all the elements work together and don't visually compete with one another.

I needed a starting point, but beyond that I didn't know exactly what was coming next. I had two weeks to get it done, and the pressure of time helped keep things focused, simple and direct. I enjoyed the immediacy and the sense of pressure of having to make decisions that felt like the right ones at the time. Good design is part knowing and part feeling and making a trusted commitment to both. I have definitely become more confident with practice over time.

Nothing of any value ever comes easily and making art is no exception. If I'm not completely open to failure it might not be worth starting. You need to learn to cope with that void or you'll miss out on wonderful surprises. These actually contribute more to the work (and my understanding) than any preconceived intentions. I've never rated talent very highly. Great if you have it, but the enthusiasm to get off the couch and actually make something of value is really where you realize what you are made of.

Learn from absolutely everything: your experiences, successes and perhaps more importantly the times when things are not going so well and success feels a little more elusive. Only when I embrace this do I experience growth. Listen carefully to what you're being told, but take time to reflect deeply and very honestly on what it means for you.

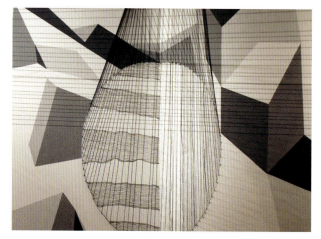

B '*Run #5*'. Completed composition.

Figure 154 Scott Anderson. '*Run #5*'. Detail into corner wall.

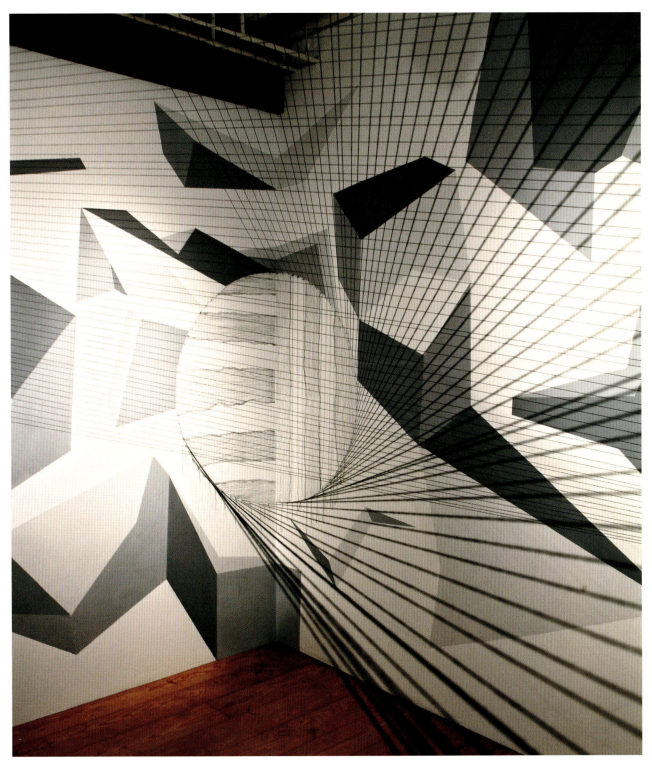

Figure 155 Scott Anderson. '*Run #5*'. Detail into corner wall.

Daniel Sousa – animation film-maker

Dan was born in Cape Verde in 1974 and grew up just outside Lisbon, Portugal. He moved to the United States in 1986 … studied at the Rhode Island School of Design. There, his original focus in illustration grew to include painting and animation.

danielsousa.com

Figure 156
Daniel Sousa.

I am an animation film-maker and a teacher. I have made several independent films that cover a range of subject matter and that employ different techniques, from traditional hand-drawn animation, to stop-motion and computer-generated imagery. I also work as a freelance director and animator for TV shows and commercials.

I believe in using the right words to say what you need to say. But you also need to use the right language. There are certain things that can only be said with images, or with the passage of time. An animated film can be like a poem, offering alternative meanings to familiar concepts, like colours or shapes. Images can be used as symbols or can simply evoke feelings or emotions that words are otherwise inadequate to describe.

The creative process is always messy. There isn't one true path that leads to making great work. Sometimes concepts come first, and I try to find images or scenarios that can allow the ideas to take form, and sometimes images lead to stories or sequences. And if I'm really lucky, the whole thing emerges fully formed and in focus. But more often than not, it starts with a very small but powerful seed, be it an image or a concept that requires a lot of exploration, experimentation, and patience to bring to fruition. I will do countless sketches, write a variety of scenarios, make rough test animations, play around with sounds, and try different materials and techniques. With perseverance and humility, there's usually something good at the end of the process. Animation is a very time-consuming endeavour, so it's also very important to try to hold on to that initial spark of inspiration through the entire process. A good test to find out if the work is finished is to ask myself whether the final piece was able to capture the essence of that spark.

Instead of focusing on originality, which I believe is an extremely over-rated quality, I try to ask whether I'm being honest in my work. That usually helps me in every decision along the way, from visual composition, to story-telling, editing, and sound design.

I started my career as a painter, and although I still approach everything I do from a strong visual foundation, the challenges of film-making can sometimes be very different. I have often designed compositions that looked great on their own, but that didn't work in the context of a scene, because they could have ruined the continuity of the storytelling, or stood out in other ways. I always find it helpful to create rough animatics, or video storyboards, before getting too far into a sequence. They don't take very long to make, and often answer a lot of questions or reveal upcoming problems in the edit that would otherwise go unnoticed.

Anything that's worthwhile requires work and perseverance. Strive to do great work, but be aware that it won't be always easy or fun. Failures and breakthroughs tend to balance each other out; so don't put too much emphasis on either.

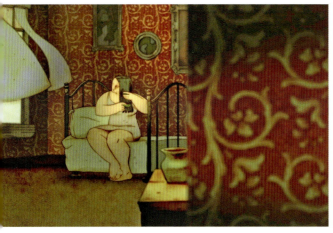

Figure 157 Daniel Sousa, 2005. *'Fable'*. Film still.

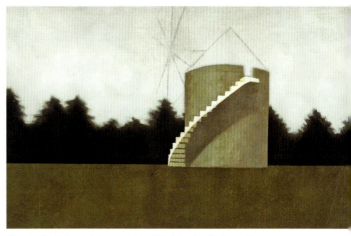

Figure 160 Daniel Sousa, 2007. *'The Windmill'*. Film still.

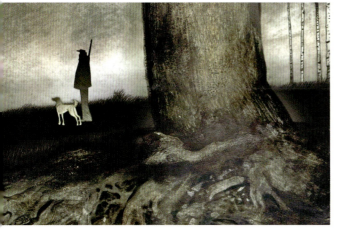

Figure 158 Daniel Sousa, 2005. *'Fable'*. Film still.

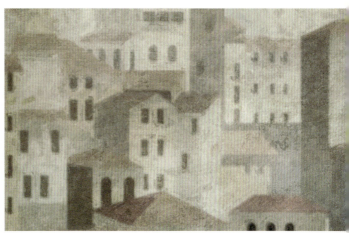

Figure 161 Daniel Sousa. *'Drift'*. Film still.

Figure 159 Daniel Sousa, 2005. *'Fable'*. Film still.

Robert Callender (1932–2011) – sculptor and painter

Robert Callender's words from DVD and exhibition catalogue. *The Making of 'Plastic Beach'* 2003–08. Comments by Liz Ogilvie (LO), August 2011.

The making of 'Plastic Beach' was inspired by observations made over the past thirty years. It is a five-hundred-piece floor installation. Materials are cardboard, paper, paint, marble dust and adhesive. The project took four years to complete and was designed to draw attention in a graphic way to the state of our coastline. The horrific assortment of plastic is quite alarming. Debris is both commercial and domestic but primarily commercial, reflecting the nature of our society.

> **LO** *Robert moved from being a painter to working in 3D and making installations. He moved with the times, but not consciously, it just happened that way. As any artist worth their salt knows, you just follow the work and you don't know where it's going to lead and what interests lie ahead, you just use your instincts and look ahead.*

Figure 162
Robert Callender

In 1970 we were given the keys to a bothy at Stoer Point (Sutherland, Scotland) and since then that has been the main focus for the work that I've been doing.

The very early work when I first went up was making paintings on the beach and along the shoreline. I kept the idea of working between high and low tide. It was very important that I had a restriction of the area where I would be making work. These were large paintings, about 14–18 ft long and about 6 ft high.

> **LO** *Reflection is extremely important. I think if you look at art today, there are a lot of very good contemporary artists around but there are some who jump around from one idiom to another and I just couldn't do that. It's a slow process and that's the way I've been born and taught into the work. You learn by doing and you move the ideas forward. Robert was very much the same. He became obsessed with one area, the shoreline, and within that his work really moved. Whether we like it or not it keeps abreast of the times. You're always finding new materials and new things to say. Robert's work now reflects on the state of the shores around the world and the environment. He didn't start out to become an environmental artist. He just did what he knew and kept doing it.*

The landscape was beneath my feet instead of stretching out towards the horizon line. It was very immediate, so I stuck with that. I learned a terrific amount. The beach paintings became paintings of rock pools and I took a lot of photographs of the beaches to record what had happened.

The beach in 1971 was lined with driftwood, but that isn't the same now. You have to go a long way to find a piece of driftwood now.

The idea of continuing to make fairly tight paintings of beaches and their structure ... of keeping on doing that, and doing that, and doing that, was not going to develop the work in the ways I wanted the work to develop.

At the Edinburgh College of Art where I taught, we started paper-making. I became frustrated by the rather nice bits of paper people were making; A4 sheets with petals pressed into them and so on and I thought OK. But the Chinese and Japanese made some extraordinary structures, furniture and so on made of papier mâché and I thought there must be something in this. At the same time as this was happening we had a wreck up at Stoer Point. It went down with all hands and five people died. By the time we got there, there was lots of flotsam and

Figure 163

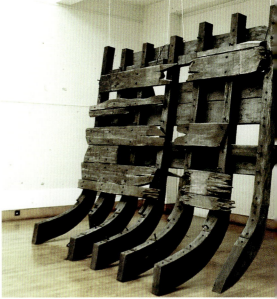

Figure 164

jetsam coming ashore from the boat and I thought I'd like to make a memorial or some kind of homage to people that work on boats, so I decided that I needed to make some structures from paper. So that's how it started.

I could move large structures around easily because they were so light. I think everybody thought I was mad because I kept making these white elephants that nobody wants, but that's fine, that's not what it's about, selling your things, it's about carrying out the ideas you have. It kind of grew, I had a couple of big shows and that spread the knowledge of the work.

As you keep going back to the same place over thirty years, you wonder if you can keep developing ideas continuously. One of the major changes we found was we weren't finding the timber we needed to light the fire, cook the food, and repair the place. There's no electric light, there's a stream we get water from, and we cook on the fire. Now we have to adjust because there's no timber on the beach. So we have to think of other methods.

The timber on the beach has been completely supplanted by pieces of plastic. All kinds of forms, huge containers, basically from the oil industry, I suppose: masses of netting, tangles of ropes that look like amazing tapestries.

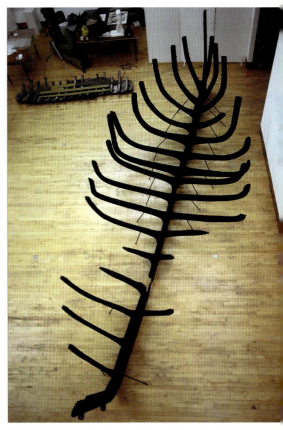

Figure 165

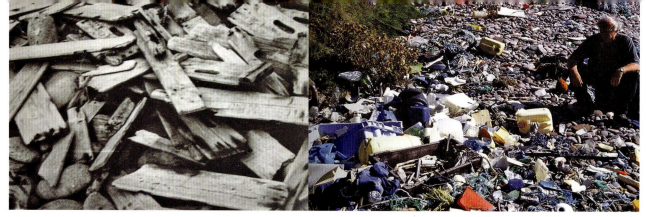

Figure 166

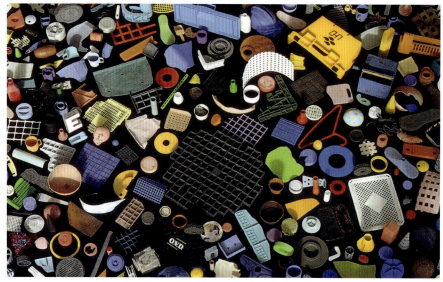

Figure 167

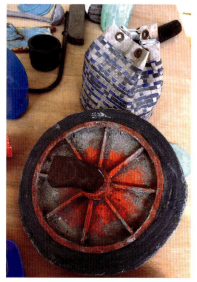

Figure 168

Figure 169

Figure 170 Figure 171

Every year it becomes more and more. As a lot of urban beaches get cleaned … the interesting stuff is cleared away and makes them rather dull places.

Nothing has been removed here (Stoer Point), and this piece ('Plastic Beach') is really rather important as a reflection of what is happening all around our coastline I guess. I think that the place has become very important.

A lot of people ask 'Why is it you do what you do?' ('Plastic Beach'). Why don't you just pick up the plastic off the beach and set it up instead of the objects you make. The answer to me is quite simple, I could do that and a lot of artists do use found material, some do it because they can't do it any other way, others maybe like Joseph Bueys imbues the material with something very special, which is marvellous. My reason for making what I find is simple, I'm a maker and I just couldn't do it any other way. I have to make these things. It's kind of a test in a way. I'm fascinated by what hands can manage. It's not just hands, of course; it's coordination and some kind of brain working behind it all. It's not that the things have to be photo-realistic or whatever, but it's important that the objects capture the mood and feel of these materials.

Restricting myself to just plastic, the parameters are narrow. It was a real challenge making 500 pieces and it made me look really hard at the structure of a beach from high tide to low tide.

Making is just something that has to be. It's just something that I do and you have to stand by that. I think it's important and it keeps me out of an awful lot of trouble, I think!

The marvellous thing that seems to have happened in the arts in my era: film-makers, painters, poets, writers, or whatever, there aren't boundaries anymore, and people can slide across and cover a whole range of areas. Not only that, if you have an idea and it isn't in your field, you can always find someone who can do it for you technically. This is a very noticeable change in the last 10–15 years, one notices that it is about ideas: if you can make it, you can make it, if you can't, you get someone else to do it for you. But it's very important that it's my hands that make it. You see students today moving their ideas across areas and getting all the help they can get to carry them out. It's marvellous.

Author's note *Robert Callender made all 500 'Plastic Beach' forms out of paper. They are beautifully crafted and painted by hand; each piece became a new object, full of visual and tactile surprise and emotional wonder.*

Esther Cohen – graphic design

I am a teacher and visual artist and I live and work in Scotland. I graduated from Duncan of Jordanstone College of Art with a master's degree in fine art in 1995. Below are recent examples of graphic design work I completed for The Pitclay Gallery and Puppet State Theatre Company's production of *The Man who Planted Trees*.

I use art as a language when I'm designing. It helps me to come up with ideas when starting to make the work. It doesn't matter if what I'm looking at for inspiration is natural, man-made or digitally created. It helps me to make sense of the visible world. This is important when designing a series of works for different purposes with all the different requirements involved. Using the language of art and design – visual language – allows me to read the visible world holistically and not in disjointed or fragmented ways that can confuse rather than inform the work.

The two posters for the Pitclay Gallery (Figures 173 and 174) are examples of how I use visual language to communicate different characteristics relating to the poster themes.

Figure 173 shows examples of two ceramic pieces. I photographed the boat in the first poster at an angle so it would give the illusion of depth and dimension, as if the boat were sailing out from the two-dimensional space. I then tried to integrate it with the map, visually connecting the lines of the road with the lines that we might see reflected on the surface of water. The gallery's location is near the sea.

Figure 172
Esther Cohen.

Figure 173

Figure 174

The second poster (Figure 174) is for a painting workshop at the gallery. The image is intentionally framed by two black rectangular shapes so it retains its two-dimensionality and can be immediately read as a painting, while the colour of the painting is visually enhanced by using black rectangles. The colour of the text ties in with the colour of the painting, giving the poster visual continuity, making it easier to read at a glance.

The Man Who Planted Trees is a puppet show based on a story with an environmental theme that crosses generations. I therefore did not want the poster (Figure 175) for the show to appear as if it had been designed just for children. With a timeless quality, the style of image was intended to appeal to the different ages in the audience: children, parents, and grandparents. That's why I used reference to a painting and not a photograph as a background for the poster.

The play is set in France; it makes reference to trees and the wind, and includes the scent of lavender. This would inform the composition of the work; including colour, use of shape, layout, text and content.

I selected as few components as possible and then organized them in different ways for different purposes (poster (Figure 175), flyer (Figure 176), programme (Figure 177) and advert (Figure 178)). Inverting, reflecting and repeating images, using fonts with appropriate style and colour, selecting shapes and textures that would produce subtle variations and create a visual theme for the show were all considerations when I was designing the work.

In the poster (Figure 175) I chose to reverse the viewer's expectations by having the puppets standing still instead of being animated. This balanced well with the dynamic quality of the background image. I also hoped this would enhance the magic of the puppets coming to life during the performance.

Figure 175

Figure 176

Figure 177

Figure 178
Brian Fischbacher.

The process of making work is the way to build knowledge; consciously using visual language regardless of a work's subject, medium or dimension so it nurtures your vision, skill and self-discipline.

Drawing is very important to the way you want the image to feel, what sense or response you want the viewer to experience. That's got a lot to do with intention, and personal expression – what you want to say. Composition is the skill of drawing together the different elements into a whole for that intention to be expressed effectively. Drawing for me doesn't mean being a wonderful draughtsperson, although I do admire that skill immensely. Salvador Dalí said, 'don't worry about perfection, you'll never achieve it.'

For me, drawing is not about copying something. It's about making something you want to say visible and understanding how to say it in non-verbal ways.

The designs include text, but the text supports the images. It's about achieving a unity and sense of balance between the elements used. The selection, position and placement of text are primarily visual.

I know when something is complete when I have considered all the elements that need to be included and have gone through a process of describing all the different permutations that might be possible in the time I have. This stage will also push boundaries through drafting out ideas, reflecting on past practice, to make the present idea visible. It's as much about learning how I deal with creating a solution to a problem as it is about making and designing something. It also frees me from pre-determined ideas that can stick in one's head, making the work predictable and the making process tedious and uninspiring.

For me, it's about finding the right visual solution in sync with a feeling I have for the initial idea at the start of the process. I know it when I make the feeling visible, the work 'works' and then it's time to show the work, make it public. I find starting a project disorientating sometimes, and working through the making process can be challenging, but at the same time, it's an immensely satisfying process. I always look at it as a journey of discovery. It's about achieving a kind of balance for myself.

The basic communication skills you learn through using the language of art and design not only helps you deal with finding positive solutions to an incredibly wide range of problems in any profession, it can also give you a great sense of achievement and pleasure that can last a lifetime.

Figure 179 Liz Ogilvie.

Liz Ogilvie – installation and performance

Transcription from conversation with Liz Ogilvie (LO), Scott Anderson (SA) and David Cohen (DC). Liz is also commenting on Robert Callender's work.

Sea Loft, Kinghorn, Fife, Scotland. 15 August 2011

'For over thirty years Liz Ogilvie has been deeply involved in a creative investigation into water and humankind's relationship to it ... Her work has been based on empirical research and is now becoming more widely recognized as a practice which manages to explore the nature of the world and its matter very directly, using universal raw materials.

The observational characteristic of her work is of increasing interest to anthropological research. How art and anthropology can be part of the same investigative and interventionist agenda that could be put in either anthropological or artistic language illuminating, for example how people dwell in the world and how to explore ... the surface play of water, improvised and ambient sound and refractive and projected light. Through this Ogilvie illustrates that her empiricism can be experienced, understood and applied in both artistic and scientific terms; using a visual language where the rational might contend on equal terms with the intuitive'.

Henry Moore Foundation Grant Application, 2011.

LO Robert moved from being a painter to working in 3D and making installations. He moved with the times, but not consciously, it just

happened that way. As any artist worth their salt knows, you just follow the work and you don't know where it's going to lead to and what interests lie ahead, you just use your instincts and look ahead.

SA *You've been dealing with the same ideas since the beginning.*

LO Yes, the themes are the same, but within that you investigate further and take the ideas further and your ideas move within the subject matter, things are not static. Certainly not in our case. We would never have contemplated thirty or forty years ago what we'd be doing now, but it's what we do, it's what we do best.

SA *It's challenging with students to teach them the concept of time. How long it takes to achieve anything of real quality. With technology, changes can be made instantly without time for reflection on what was created.*

LO Yes. Reflection is extremely important. I think if you look at contemporary art today, there are a lot of very good artists around, but there are some who jump around from one idiom to another and I just couldn't do that. It's a slow process and that's the way I've been taught. You learn by doing and you move the ideas forward. Bob was very much the same. He became obsessed with one area, the shoreline, and within that his work really moved. Whether we like it or not, it keeps abreast of the times. You're always finding new materials and new things to say. Bob's work now reflects on the state of the shores around the world and the environment. He didn't start out to become an environmental artist. He just did what he knew and kept doing it.

DC *His vocabulary kept building. After a certain period of time an artist doesn't necessarily look for new ideas. After about forty-five years you get the confidence within yourself, because you focus on your interest. That interest is a lifetime involvement. A lot of different things can come into that.*

LO Yes, there are outside influences, but basically it is all within. The best artists bring out internal poetry and curiosity.

DC *But you also have craft. A lot of people who delve into the conceptual way of thinking can go so far. The bigger our vocabulary becomes, the more selective we have to be within that.*

LO I think that's what artists are particularly good at. The best of them are particularly selective, and to make decisions about your work, that's vitally important whatever idiom you're working in. The work I make is constructed by other people, but all the decisions I have to make: getting the right people, drawing up exactly what I want, making sure it works by experimenting in the studio. You can't leave anything to chance. Whatever idiom you're working in, you like the unforeseen elements you discover in the work. You discover new things in the work itself.

DC *In a visual sense there is still craft. You may have jumped from being a person who is actually drawing to being a director. You are selecting people who have a certain craft, whether it's on the computer or whatever it may be, and they are capable of understanding what your idea is about.*

LO Yes, you've got to know and you've got to be precise.

DC *Together they all contribute to your idea. At certain times they contribute something to your idea that will trigger something else.*

LO Yes, you're open to new ideas. I think that you can look at my work now and you can look back thirty years. I think that what I've done in the last decade, when I had this show in the warehouse here in Kirkcaldy, I was in it for three months, I could study it and stand back from it. This was a privilege, because I learned a hell of a lot about the work and how the public responded. Seeing

Figure 180

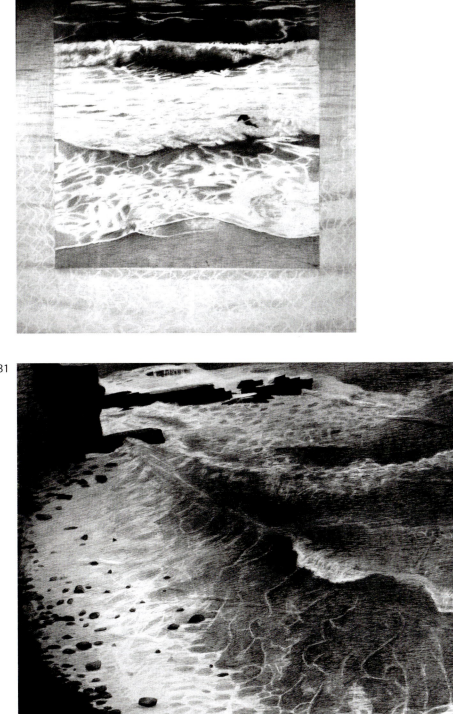

Figure 181

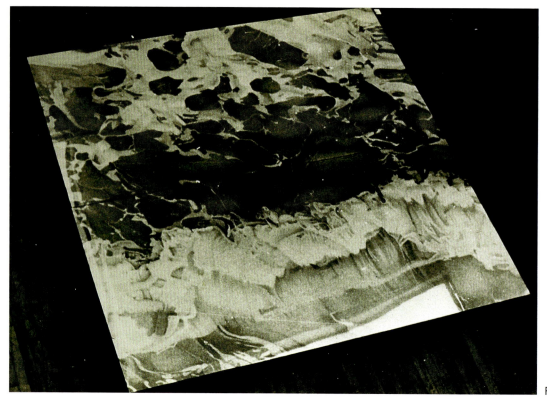

Figure 182

how other people saw it was a big learning curve, so that was very valuable. And then when I had the show at Dundee Contemporary Arts, then in Japan, I had a better grasp of what I wanted to achieve by using all these different professionals and how to perfect that, it is just like drawing in that you're doing a lot by instinct even if you are a director, but then at the end of the day you are pulling it all together and it has to work together. I'm not necessarily doing it for the public, I'm doing it for myself, but then I learn a lot from the public and how they respond is interesting. It encourages you to move on and gives you the confidence that you need.

DC *One of the most interesting statements that comes from an artist working on a piece is when they say, 'It works.' What does that mean? It means that the ideas pull together and that at the time that is the conclusion of that and it communicated your intention and you say 'It works'. The public never really comments on that aspect, when the artist says they worked on it until they were convinced that it works.*

LO Yes, it's the idea that no artist is entirely sure what the finished work will look like when they're working on it, but as they instinctively work towards some sort of conclusion they trust their experience and their instinct.

DC *In teaching, when you are confronted with a new group of art students coming in on the first day, what do you say to them on a fundamental level?*

LO It's very important that you have good staff, not just Sunday painters, but artists who are very involved, because a lot of art colleges aren't like that now. Teachers have to be artists and this is important for the students to know, to communicate their total involvement. This is important, and also the fact that even at our age we're not totally confident about what we're doing

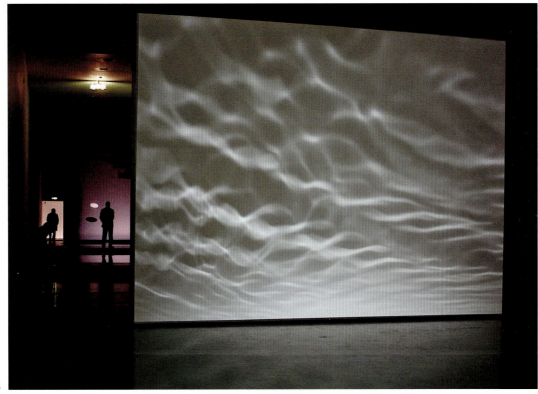

Figure 183

sometimes, so the importance of trusting yourself, you have to instill that confidence in young people, and also learning how to learn. You learn a lot by listening to people and talking about the art as we do and I think there should be more discussion as young people start off, so that they can begin to form their own opinions, because I don't think they've got that. The school curriculum knocks it out of them, they don't have the confidence.

DC *Are there common fundamentals that we can communicate to students? I think a lot of students get lost very quickly in the first year.*

LO Yes, it's a bad year, a difficult year. But if the course is well designed and they're learning a lot of basic skills, particularly drawing, a very fundamental skill – it's not necessarily to do with the marks you make, it's to do with a communication, your brain communicating with your hand, what you're seeing. If they're working from life or whatever subject they're interested in, it's learning ways of seeing, and their own way of looking at it. They have to understand how other people have gained through this traditional start. All the artists we know have learned in that way, so there are no short cuts.

DC *There was a time, for example, when Picasso was painting like Toulouse Lautrec. Students were learning from each other. Duchamp came along and turned the whole thing on its head. Students were encouraged to take their idea, to know themselves and develop their idea into self expression.*

LO So that's what you need in the first-year course. To learn to look at your own ideas and develop them for yourself, but you also need to be looking at other artists' work and learn from them, you need a lot of guidance for that.

Figure 184

DC *There was a time in the US, around the time of Jackson Pollock, when they pretty much wiped out all life drawing and that way of studying.*

LO Yes it's come and gone, but in Britain it's still there. Edinburgh College of Art is still very good; they work at life drawing right up until third year and life drawing in the broad sense of the word and a strong sense of drawing for its own sake, what's in your heart. That's a very important, basic language that you've got to learn. It can be taught to a certain extent, but it has to be explained that each individual has to find their way and find their own language within drawing and find out what they want to make their work about.

DC *I feel that it is important that a student learns a language that can be applied to any visual discipline: graphics, television, computers or whatever. But basically within the language you are trying to express yourself through the idea. Once you focus on the idea you have to have the language in order to express that. After a time you hone in and start building your identity through basic language. That basic language, I think, is developed not only through a traditional way of looking at things but also through mediums that we only started fooling around with in the 1980s. And here thirty years later everything is turned on its head. Students go right to the medium and start fooling around in Photoshop and that sort of thing.*

LO Yes. This is evidenced in schools, where students can't read and can't write. There's too much emphasis on computer studies and they can't add up. Art suffers in the same way. Through practice it heightens your perception, you do this daily, your whole being is honed to this practice of expressing yourself in this way.

SA *There are a lot of internal qualities that you have within yourself. I learned a hell of a lot more in this regard from running to a fairly high competitive level than I ever really learned in art school.*

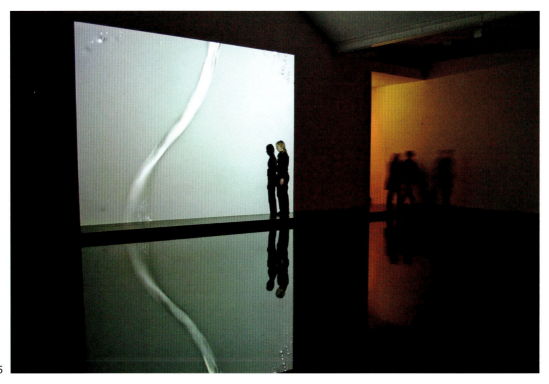

Figure 185

LO Yes, you can understand that.

SA *It takes a tremendous amount of energy. I learned a huge amount from friends and coaches, but at the end of the day it was about me: what I understood about what they were saying. As many books as you have on your shelf about art, there are just as many written about how to run faster by some of the best runners that have ever lived, and what strikes me is that there is no one way to greatness, but there are some basic things that everyone must have within them, and that includes a desire to work really hard: motivation.*

LO Yes, motivation is so important and you automatically acknowledge that this is what you do. So it's imbuing a sort of lifelong desire and drive, but in a way it's something that people have to have in them, but through encouragement you can nurture it.

SA *On the highest level, the word 'poetry' seems to keep surfacing in your and Bob's work. I see poetry in a literary sense as being the highest form of how we use language. How do you see it in a visual sense?*

LO Well, it's a kind of distillation of your ideas and your knowledge and your experience and so there are parallels there. You get a few words that are so perfect you can't imagine it being any other way, and it's the same with an artwork at its best: it couldn't be any other way; it's come about through the artist's complete obsession and putting their whole heart and soul into it and putting a lot of slog into it as well. These few lines of poetry, whether it's Tom Clark or Douglas Dunn, they couldn't have done that without working hard at it and distilling it down. Inspiration is a superficial thing, it takes hard slog and decision-making to get it down to that perfection.

DC *The running analogy is interesting, but running is about competition: even if you don't win, you compete against yourself and know within yourself that you have done your best and get satisfaction from that. In art there is no 'winning'; there's just the fact that you want to express yourself and put your work in front of people. The object here is communication.*

LO I've seen Bob and I know I also get a lot of pleasure by standing back and seeing how people respond to the work. They understand and see all the work that's gone into it, but more importantly, they see the expression and understand what he's saying, so all the work that's put into something doesn't matter, what's important for the public to see is the expression in it.

DC *The scale of your and Bob's work I feel is important with respect to communication with the public.*

LO Yes, but you don't consciously go out and say 'I must make something big.' The work leads you to that conclusion, that this is the scale, proportion, design, that this is the way it must be. The scale relates to the idea for the work being made. Ideas come on that scale because that's the only way they could be. It's very important that the idea is developed that's right for the space and that the space 'speaks to you'. Gradually you understand the space, you work in tandem with it in many ways.

SA *How long will you spend in a space to understand it in preparation for new work?*

LO Well, with the new space where I will be exhibiting at P3 in London, so far I've been three times and we've had meetings. I've taken photographs and I have the plan and how I go about it is quite interesting. I use my studio space as the equivalent of the exhibition space, so I begin to work out the proportions in my studio and play around with that. Because I'm at the stage where I know vaguely what I'm doing, it's at the stage where I'm pulling it all together, the different components – and there are a lot of them. Again I'm moving forward because it's a different space. I'm working with ice this time, doing a lot of filming and photography in Greenland. I'm interviewing, looking at ice floes, and there will be material coming to the gallery in real time, using high technology, radar and satellite, using ice melt, so there are a whole lot of different components, and filming and interviewing the Inuit in the ice floes themselves. I'm fascinated by what we learn through looking and reading, the Inuit can look and track ice intuitively. We could only do it through studying it, but they live with ice, with this knowledge. It's what they've learned directly from the subject, something they possess that nobody else does. It's an extraordinary skill and that's what I'm interested in, talking to the Inuit.

DC *The impact of the changing climate and environment must be challenging for them.*

LO Yes, but they are used to change, water becoming ice, ice becoming water. They have learned to adapt and accept change. I went to Greenland because I was interested in the environment there. That is my subject matter: water, ice, water circulation, and I surprised myself by becoming interested in the human perspective, so I've learned a lot. I've added a new element in my work, by allowing my work to speak to me.

DC *A scientist would communicate their understanding of these issues in very different ways from an artist.*

LO Yes, the scientists I'm working with understand that and see the importance and value of an artist being able to communicate about these important issues in a different way from them. Scientists are doing fantastic things, absolutely amazing and they're as obsessive about it as we are, but this isn't part of their ability to communicate it. People experience my work through their senses and perhaps then they start to think about it and about the environment.

DC *The new exhibits at the National Museum of Scotland are particularly engaging as a three-dimensional interactive experience.*

LO Yes, and a lot of the people who now work in museums have come through the art college system, whether it's design or whatever, they're the ones who are designing these displays.

DC *The student artist has to appreciate that much of the experience of creating and reflecting on their work must be done in isolation.*

LO Yes, it's that space that you're familiar with, that you go to every day, and that's what happens: there's a kind of warmth that comes over you and that's the signal to get moving.

DC *Any artist who is constantly at it knows that those times of isolation produce a clarity that is very important, but it's a difficult point to get over to students, it's not something you can learn and no teacher can give it to you.*

LO Yes, you have to find it yourself. You have the blank page and you have to build from nothing, although you do have a starting point from previous work.

Figure 186
Suzy Rivitz.

Suzy Rivitz: architect

After a brief law career, I went back to architecture school and graduated with a master's degree in architecture from Yale in 1993. For ten years I practised architecture with the Boston firm Flansburgh & Associates Architects (FAA), where my focus was on educational projects, primarily publicly funded schools. I felt that designing good publicly funded schools was a civic benefit, although the public bid process that awarded the building contract to the lowest qualified (often barely qualified) bidder made the construction phase unproductively antagonistic. We tried to create welcoming environments given limited budgets and other construction constraints. (Figures 187–190.)

The colour themes and open feeling in the large public spaces continue throughout the building. This is where we chose to spend the 'extra' from our limited resources. In addition, all classrooms have large windows to let in as much natural light as possible.

For the past eight years I have been with Genesis Planners, where I have worked on a wide variety of projects – designing and managing small renovation projects and acting as the owner's representative on larger university and hospital projects where I coordinate project design and construction, making sure the owner's needs are set forth in the architect's design and built by the contractor. We are currently developing a pocket community in West Concord where the houses are designed to be potentially energy self-sufficient (Figures 191–192). For this project, Concord Riverwalk, we have hired a talented architectural firm, Donald Powers Architects in Providence, Rhode Island.

The houses are super insulated and designed to be potentially net zero in terms of energy usage; most purchasers are choosing to install solar thermal and photovoltaic systems. The scale of the houses helps to foster community among people who did not know each other before. For this project I am coordinating the building contractors and sub-contractors, and acting as liaison with the purchasers. This includes helping the purchasers finish the interiors of their new homes (Figure 192).

Figures 187–190
K–8 Malden Beebe Elementary
and Middle School, Malden,
Massachusetts.

Figure 187
Two-storey lobby with corridor
overlooking the lobby. This is
one way to keep a big, boxy
building feeling open.

Figure 188
Cafeteria with corridor bridge
from gymnasium opening
onto the small city park
adjacent to the school.

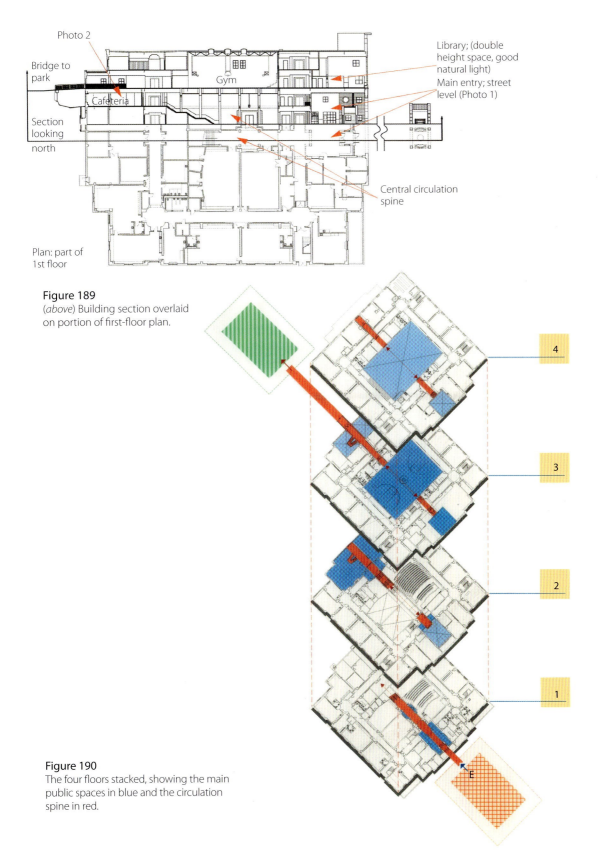

Photo 2

Bridge to park

Gym

Cafeteria

Section looking north

Library; (double height space, good natural light)

Main entry; street level (Photo 1)

Central circulation spine

Plan: part of 1st floor

Figure 189
(*above*) Building section overlaid on portion of first-floor plan.

4

3

2

1

E

Figure 190
The four floors stacked, showing the main public spaces in blue and the circulation spine in red.

Figure 191 View from community fireplace to several of the units, two completed and one nearing completion.

Figure 192

Scale and light are the key design parameters for me. An architect has to decide for whom she or he is designing the space – are they full-time occupants or primarily short-term visitors? Are you making a political statement or providing a 'nice' place to 'be'? I want people to like being in any space that I have helped to design, whether it's a pre-school classroom or an office cube. These are spaces where people spend a lot of time (unlike a museum), so comfort takes precedence. A comfortable space does not, however, have to be bland. While good architecture certainly can't guarantee happiness, being in a bad space can certainly sour a mood.

Figure 193

The challenge in this project (Figures 193–195), on a limited budget, was to turn a generic office space into something with a little more punch. With one gesture of skewed geometry (often used in contemporary architecture) and a punch of contrasting carpet and paint, this otherwise awkward office entry became a little more alive.

Sometimes it is a matter of taking words and making them into images – we designed eight schools for the City of Waltham. Throughout the industrial revolution, Waltham was known as Watch City, so I converted those ideas into a school plan based on the face of a clock. The final design does not read as a clock, but it helped generate ideas, which allowed our team to discuss what parts of the design made sense and what did not.

For interior office work, which is often fast schedule, with a low design budget and minimal construction budget, I just want to make sure that spaces are as gracious / workable / enjoyable / even fun as possible. For the larger school projects when I was at FAA, we always worked in teams, so the ability to listen, explain and compromise was critical to moving projects forward.

When I started in architecture, we were still creating hand drawings and models. While rough models are still very important in understanding the space you are designing, much of the design visualization in the field has shifted to computer-aided design and three-dimensional modelling.

It's important to listen carefully to clients and pay attention to the realities of the budget. It is their money and they have to live in the space, so it is important to respect what clients say. It is equally important to question clients' assumptions with which you might disagree to arrive at the best possible design solution.

The end product of an architectural project results from a balance of programme, design, budget and schedule. And it is often the architect who must juggle the roles of many players – client, design team, outside specialist consultants, contractors and local building officials.

It's important to realize that it takes years to become good at anything, including architecture.

Architecture can differ from other visual arts, as its creation often requires a team of individuals, each with their own spatial and visual ideas, to work together. In large firms a senior designer will set the tone, but there are so many details to be created that many voices can be heard. This does require a senior designer who is comfortable with delegating parts of the project. And at some point sometimes you need to let an idea you love fall by the wayside, maybe to be resurrected in another project.

Figure 194

Figure 195

Nathalie Ferrier – textile and fibre artist

I live and work on Cape Cod, Massachusetts. I received my MFA from MASSART and am a faculty member at the Provincetown Art Association and Museum. I began work as a fashion designer / modeliste based in Paris, making clothes for haute couture.

While growing up in France, I spent a lot of time with my great grandmother, who crocheted and knitted daily. She taught me early on. She would crochet blankets, spending over a year just to make one. I use crochet in most of my pieces. Crochet is the bond; it connects, supports and holds the work together. I can spend several months working on just one piece.

My childhood seems to have left the strongest imprint on me. The simple craft techniques acquired in my early years and my interest in textiles still influence my artwork today.

I don't use traditional art materials for the making of my artwork. My home and its surroundings provide most of the materials and objects I need. I salvage plastics, containers or wrappers, duct, masking and electric tapes, yarn, thread, ropes, wood, trash, house paint, dishes, used teabags, fabrics etc.

I keep everything I select close at hand in order to look at them and think about what they mean, and grab them when I decide to include them in a piece.

My work is also often inspired by words, sentences from poems or essays I read. I write them down, pin them to the wall and sometimes they take shape within my art. I also like thinking of the titles of my pieces.

The recycled objects release information and stories about me. In 'Spider Auto Portrait', the thread spools have labels that read 'La Magicienne', 'Le Nain bleu' (the blue dwarf). Those words add a fairytale connotation to the piece.

My choice to re-use everyday materials gives an ironic and critical stance to my work and offers a more informal approach to it. For instance, in 'Untitled: Heart, Lungs and Arteries', part of an old shirt is used to make the lungs and part of an old dog ball is crocheted and turned into a heart.

Figure 196
Nathalie Ferrier.

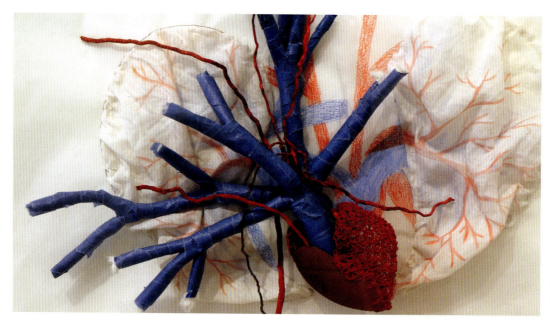

Figure 197
Nathalie Ferrier, 2011. 'Untitled: Heart, Lungs and Arteries.' Graphite pencil, thread, tape, fabric, plastic ball, branches. Ex Voto series detail, 76 x 65 cm.

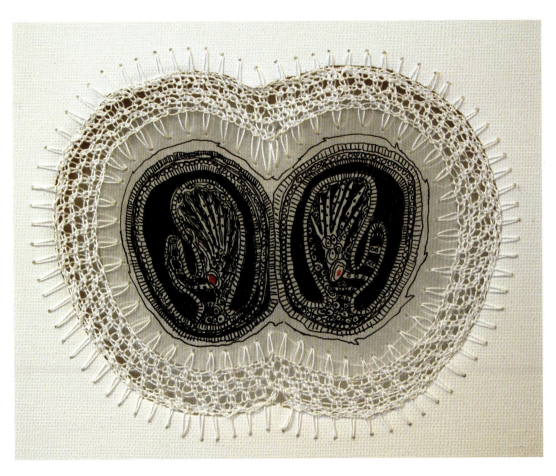

Figure 198
Nathalie Ferrier,
2011. *'Adam dream fruit'.* Wax paper,
ink, thread. Ex Voto
series detail, 25 x
25 cm.

Figure 199
Nathalie Ferrier.
'Spider Auto Portrait'.
Detail. Cotton thread.

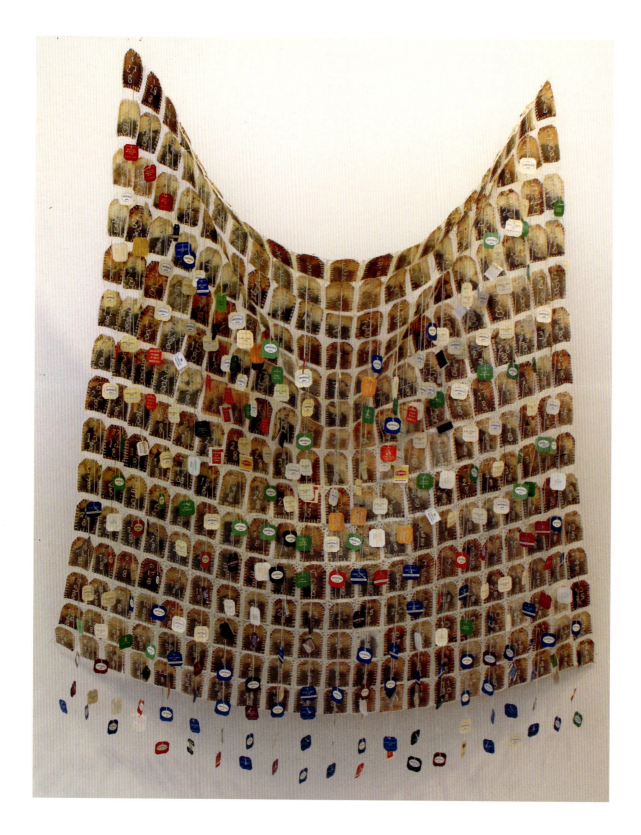

Figure 200 (*left*)
Nathalie Ferrier,
2008–09. '*Calendar Blanket*.'Teabags
and crochet,
182 x 121 cm.

Figure 201 (*right*)
Nathalie Ferrier,
2008–09. '*Calendar Blanket*' detail.
Teabags and crochet,
182 x 121 cm.

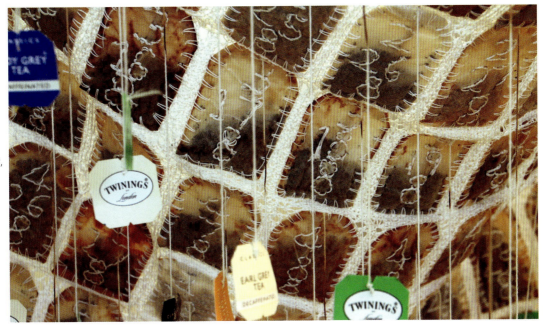

'Blanket' is a recurring theme in my work. 'Calendar Blanket' was started at the beginning of January 2008 and was continued for a year. Each of the blanket squares is a used teabag on which the date of each day of the month is embroidered. Each teabag is crocheted to the next. The final piece is the

The Ex-Voto series was created as a tribute, an offering to the body and nature. The layers of tissues that line the inside of our bodies fascinate me. They are evocative of light dresses and delicate sweaters worn one on top of the other. Arteries and veins permeate and bond our whole body, resembling vines, roots and life-sustaining trees. Organs nest among branches and roots like secret pockets.

I interpreted sections of the body, organs, articulations, bones, muscles, and tissues by applying various techniques of sewing, crocheting, embroidering, and knitting. The presence of wool, fibres, threads and fabrics intertwining with elements from nature like dry leaves, tree roots and foliage, exhibit a sustained but fragile and intimate world.

Coming from a design background, I have realized that the craft I've learned throughout my life and all the experiences I acquired working in fashion have helped me become the artist I am today.

When I get to the studio I like to have a routine. I usually make myself some tea and I start doing some crochet work. I look at what I made the day before, or pieces I finished a while ago. Routine helps me gather my thoughts. The time in the studio feels necessary for my own growth and to develop new work. I need this time to cut myself off from the rest of the world.

It's crucial to stay connected to art and other artists. I often visit museums, galleries and artists' studios. I look online and read art magazines and art books. Visual language changes with so many artists around the world reshaping it in their own ways. It is fascinating and sometimes overwhelming. Nevertheless, it's important for me to know where my contemporaries are, how they think and what they create. Being exposed to art expands my visual understanding and brings fresh air that may or may not impact on my work.

I think of making art as a global learning experience. Each subject I work on becomes to some extent an exploration, which later may bring some visual discovery.

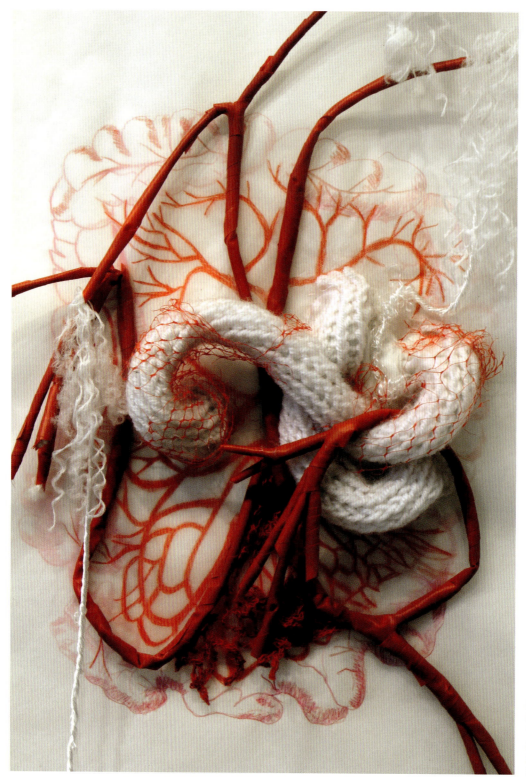

Figure 202
Nathalie Ferrier, 2011.
'*Fire*.' Graphite pencil, wax
paper, yarn, tape, thread,
polyester. Ex Voto series.
81 x 48 cm.

INDEX